Painting
Watercolour Landscapes
With Confidence

BRIAN RYDER

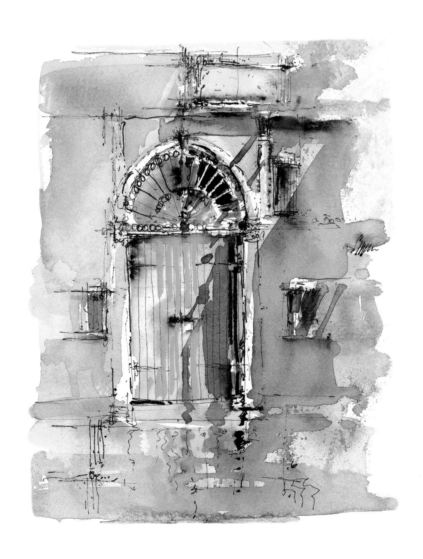

David and Charles

To Linda, all friends, family and loved ones

Please tread softly angel
Don't disturb the dust of last night's dreams
or kick the traces of discarded thoughts
But hold the stars, catch the fairies, touch the night
then paint the skies

BRIAN RYDER 2004

A DAVID & CHARLES BOOK
David & Charles is a subsidiary of F+W (UK) Ltd.,
an F+W Publications Inc. company

First published in the UK in 2005

Copyright © Brian Ryder 2005

Distributed in North America
by F+W Publications, Inc.
4700 East Galbraith Road
Cincinnati, OH 45236
1-800-289-0963

Brian Ryder has asserted his right to be identified as
author of this work in accordance with the Copyright,
Designs and Patents Act, 1988.

A catalogue record for this book is available from the
British Library.

ISBN 0 7153 1786 5 hardback
ISBN 0 7153 1787 3 paperback (USA only)

Printed in Singapore by KHL Printing Co. Pte Ltd
for David & Charles
Brunel House Newton Abbot Devon

Commissioning Editor Freya Dangerfield
Desk Editor Lewis Birchon
Project Editor Ian Kearey
Art Editor Sue Cleave
Production Controller Kelly Smith

Visit our website at www.davidandcharles.co.uk

David & Charles books are available from all good
bookshops; alternatively you can contact our Orderline on
(0)1626 334555 or write to us at FREEPOST EX2 110,
David & Charles Direct, Newton Abbot, TQ12 4ZZ (no
stamp required UK mainland).

RIGHT: **Campo dei Mori, Venice**

Contents

Introduction

As the title states, this book is all about learning to paint watercolour landscapes with standard materials and painting with confidence – and without any gimmicks that promise the moon (but rarely deliver it). Let's start by analyzing just what the parts of the title mean...

Painting... using colours on a surface.
Watercolour... artist paint of pigment diluted with water.
Landscapes... a picture of inland or coastal scenery.
Confidence... firm trust, assured expectation, self-reliance, boldness and impudence.

I can hear myself say at the start of a watercolour course, 'OK – what's the difference between a professional artist and an amateur one? No jokes here, please!' In many instances the answer is 'not a lot', and there are many amateurs who are as good as, if not better than, professionals. Professionals just earn their living from art – as a rule they discard, as do amateurs, much of what is produced – but at the end of the day, the difference is not only experience and practice: the real answer is confidence!

In my painting career I have learned to trust the art of putting colour on to paper and have become more assured about the result – now, even mistakes can be discarded with confidence. My paintings may not end up exactly as planned, but they are usually somewhere near my goal. Inexperienced and nervous painters often just 'hope the painting works', but in this book I want to take you down a pathway where you tackle each painting with more trust, more self-reliance and more impudence and assurance... more confidence. This pathway will help you obtain better results by avoiding overworked and muddy paintings because you will avoid the 'fiddling about' syndrome, starting with making the initial strokes and washes more assured and bold.

Water and oil

When I started down my pathway to painting, JMW Turner was my mentor and guide; I took to oils because that was the type of painting that I was interested in. It must be said that oil painting was, and still is, the best place to start to learn colour mixing: just add white to make things lighter – simple! If you were to persevere down this path it would give you a much higher success rate than most other mediums, and you can change things if you do them wrong. However, the more you paint the more frustrated you become as expectations rise; oils are no exception to this – and as for watercolour...

Past masters

Painted well, there is nothing like a good translucent and crisp watercolour; a British tradition at its best. The great watercolourists of the 19th and 20th centuries had no equals – even the watercolour sketches carried out *en plein air* are now masterpieces in their own right, and many of these little tinted drawings stand alongside, and with the same respect as, the grand studio works. This is where I believe most of us want our work to be – not among large Academy watercolours, but alongside other smaller paintings of similar technical competence; paintings of light and translucency – somewhere we can pitch our flag and be proud to have painted the pictures.

You can do no better than study the works of Turner, Girtin and Cotman, then look further to the Impressionists, although many only used watercolour as a preliminary to oil painting. Next, go forwards in time to the likes of Seago and Wesson to understand the beauty of the medium.

Tight or loose

Painters seem to fall into two schools – tight or loose – sometimes depending upon the subject, but mostly somewhere in between. 'I want to loosen up' are the words I hear most often, followed by 'well, within reason', but what normally follows is somewhere in between.

I am a firm believer that everyone should go out and paint as much as possible, though busy lives often prevent this. But if you want to paint better, you will always find time – at the end of the day you can't paint landscapes without painting directly from a scene, in the same way that you can't learn to play the piano without putting your hands on the keyboard.

'But I paint from photos... is that OK?'

Let me say now that I think there is absolutely nothing wrong with painting from photos... use photos for your paintings – but don't copy them. By all means take photos of the subjects you wish to paint, but get out there and actually take the photo yourself, or better still, do a sketch, or even better, do a watercolour after taking the shot.

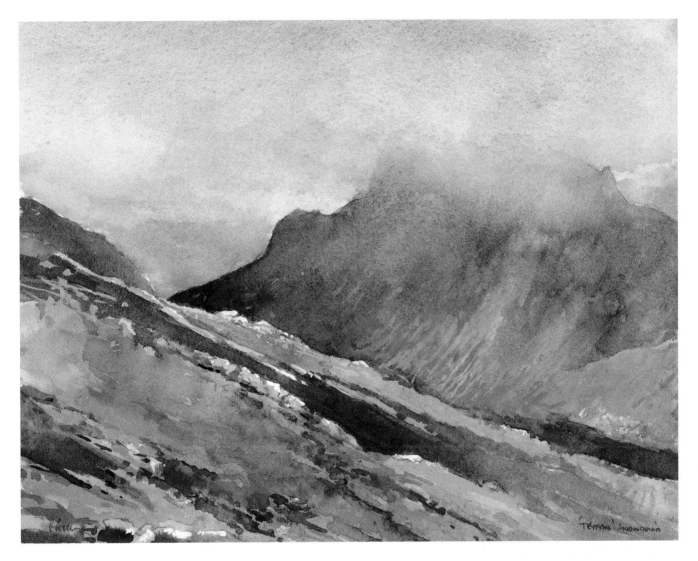

Understanding watercolour

Once you understand the basic rudiments of mixing coloured pigments with water and applying the result with a brush on to paper, you may feel you've cracked the code.

I do not believe this to be the case. To paint well, you need to first understand what watercolour does when applied to paper, what type of drawing to do to produce a painting, what basic materials you need – colours, brushes, paper.

I want you to be able not only to produce a picture, but to produce a painting that has feeling and atmosphere. This is a book about painting, not tight drawings that are then coloured with pigment: that is illustration, a subtle difference.

How to…

There are three important things in painting: first drawing, second drawing, third drawing.

Even drawing for drawing's sake will help you to achieve better paintings. 'A good drawing never made a bad painting', so it's been said, and I believe that.

For painting you need three or four decent round brushes – no flats, no tree brushes, no hakes, no gimmicks.

Tryfan, Snowdonia, Wales. This watercolour shows rugged mountains covered by low cloud.

A decent paper, a decent drawing done to the best of your ability, decent washes… you are halfway there, and this book should help you reach your goal. It's all about putting coloured tints down in a composition within (more or less) drawn guidelines with conviction and confidence.

Pushing the limits

Everybody should stretch themselves when tackling a painting. If you stick with the safe option, you will never get any better, and although you may hit upon a run of painting style that is successful, to rest on your laurels will achieve nothing. You will go nowhere!

Be prepared to have a go at something new, as complacency breeds contempt. Sometimes when I am asked to do a demonstration painting for an art club, I go out of my way to try something different: it keeps me on my toes and produces the adrenalin that stops the slapdash approach. Anyway, you can always drop back every now and then to produce paintings you are more comfortable with.

HOW TO USE THIS BOOK

In this book I have included my basic principles of painting water-colours. There are, of course, many other syles and techniques that are possible with watercolour – and I could write a whole book on drawing – but this selection should be a good grounding.

Materials and equipment

This section explores the equipment I use, from pencils, pens and other sorts of drawing equipment to paints, brushes, paper and miscellaneous art equipment for use indoors and out, including palettes, sketchbooks, bags and other bits and pieces.

Photographs and how to use them are explained, as is the quick paper-stretching method I use indoors, and how to prepare for that trip out.

Drawing techniques

This includes the pencils I use and how to make basic pencil marks, how to work outdoors, what to draw and what to leave out.

Also shown are the following techniques: the type of drawing to do for your watercolour, composition and perspective (the very basic needed to make a painting), shading and hatching, how and when to add details, and when and what to leave out.

Penwork for pen and wash is also examined – if you have never done a pen and wash painting that doesn't use pre-liminary pencil lines, you haven't lived, as it's one of the most satisfying and instant forms of watercolour.

Finally, drawing exercises will help your finished work.

Watercolour techniques

This begins with a look at translucent and opaque colours and how to apply basic washes; working wet-in-wet and wet-on-dry are next in this section. The addition of shadows, light and shade and tonal balance are then described, with illustrations of how you can get the best out of your techniques. I then look at how to paint simple skies with maximum effect, as the sky dictates the final painting.

The stages of watercolour come next, along with making marks and how to use white gouache before other techniques are examined: granulation for effect, spattering and resist for more advanced work.

Colour mixing

This short but important chapter shows how I mix the colours I use, how to fix a good water-to-pigment ratio, and gives a list of finished colours and where to use them.

Mixing media

Another short section, this covers the use of acrylic as a water-colour, watercolour with soft pastels, and other forms of mixed media that you might want to try.

Projects

This is the largest section of the book, where I have chosen ten subjects that are linked in one way or another, such as details on beach huts linked to, and contrasted with, details on a Venetian palace; intense shadows on a street scene, and how to use similar effects for a classic snow scene; a little bit of sky with a large area of mid/foreground, as in the rocks and ravines painting, to creating atmosphere with a large sky and a boat on a flat marsh with a low horizon.

Each project is in some way linked to the next, not from the easiest to the most difficult, but with a visual or a detail connec-tion; and each is preceded by either a drawing or a photograph that I have taken, to help you try the painting yourself.

The projects will build upon the techniques and exercises fea-tured in the previous sections. Referring back to these sections will help you understand when and how to use these techniques.

Gallery

These are a few paintings and drawings of my own for you to spot the techniques used and perhaps have a go at yourself.

Planning with confidence

I firmly believe that painting watercolours successfully means maximum thought and minimum work. I constantly tell people to 'Plan like a tortoise and paint like a hare' and say 'Painting is something you do in between coffee breaks'.

Oh, and something else: I mentioned the difference between an amateur and a professional – sometimes not a lot – but if there is really one thing, it is that in one hour of painting, amateurs normally plan the subject for quarter of an hour and paint for three-quarters of an hour, whereas most good professionals do exactly the opposite!

So plan carefully, make and drink your coffee, think again, have another coffee or walk away from your planned approach and/or drawing, think again, mix some colours, check that you are happy, and then – and only then – paint each stage boldly and swiftly, stop and plan the next stage, then paint swiftly again. Most of all, paint with confidence!

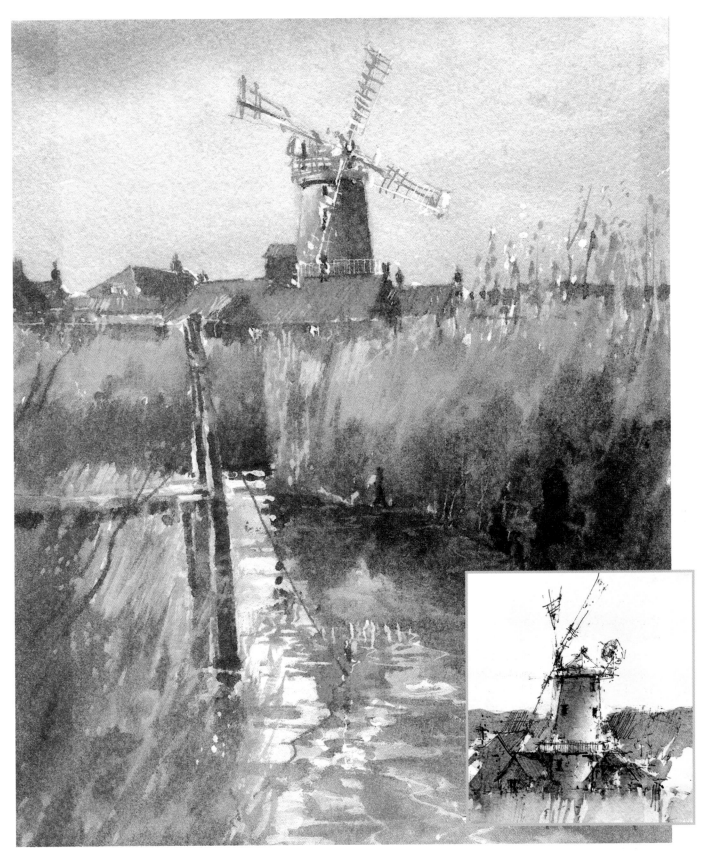

Cley Mill, north Norfolk. The main picture shows an unusual view of a much-painted subject.

INSET: A sketch of the mill from a different angle.

Materials and Equipment

DRAWING MATERIALS

Drawing, in one form or another, is essential for a finished painting. Learn to draw to the best of your ability, and make sure to practise – it will pay dividends in the long run.

Pencils

For drawing, pretty well any known-brand and good-quality pencil will be OK – I happen to use Derwent pencils. I have tried over the years using lots of grades, including special graphite types and whole lead pencils, but I have narrowed my range right down to standard pencils with very soft leads – 5B to 9B – kept very sharp.

I keep a tin filled with pencils and sharpen them all with an old metal school sharpener or a craft knife. When doing outdoor drawings, I take the tin with me containing all the pre-sharpened pencils, and just pick up the next pencil

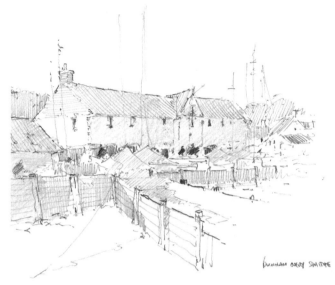

Burnham Overy. This pencil drawing concentrates on light and shade.

when the one that I am using gets blunt. This gives maximum time sketching, and is an example of planning ahead.

Why do I use such soft pencils? Well, the line can easily be rubbed out by applying very light pressure with a soft putty eraser, and a soft grade does not disturb the surface of the paper, whether it be cartridge or watercolour paper. In addition, everything from very light marks to heavy shading can be easily obtained without continually changing grades; so learn to use your pencil to its fullest extent.

Pens

One of my favourite methods of drawing is using both waterproof and non-waterproof pens. There are quite a few makes on the market, including fibre tips, rollerball types and standard pen nibs with ink chambers.

The fibre tip is the type of pen I most frequently use; it normally comes in the following size nibs: 0.1, 0.3, 0.5 and 0.7. These pens are easily transportable and do not need to be refilled, just thrown away when you are done, but they do last a long time if you replace the tops and draw lightly and with feeling; remember, you are drawing, not engraving the paper.

The rollerball and ballpoint types of art pen are becoming more readily available, and can be used as a substitute for the fibre tip.

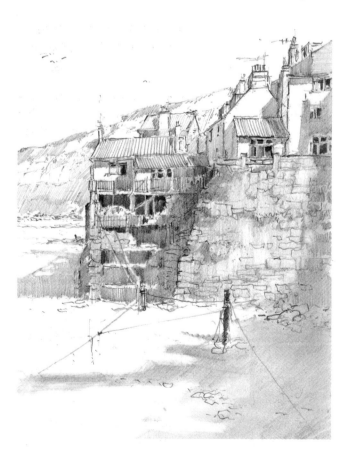

Staithes. This drawing is stronger and includes more detail.

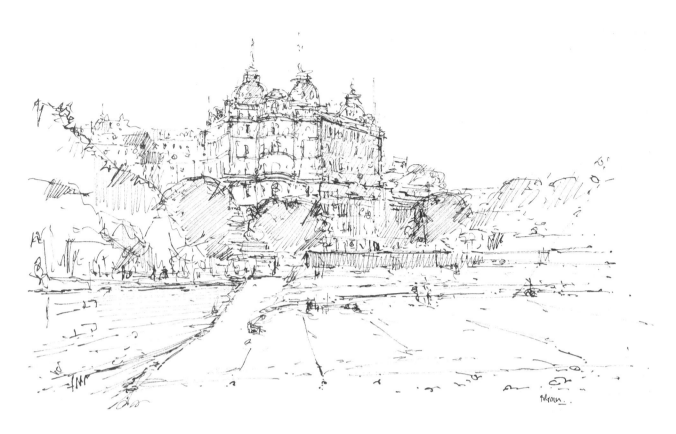

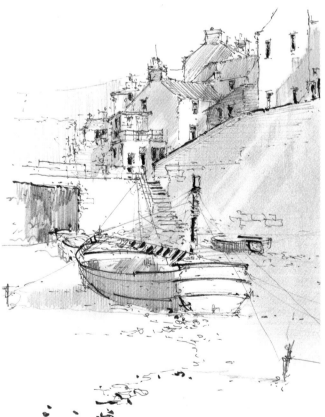

ABOVE: Scarborough; LEFT: Boat at Staithes. The free drawing above used 0.1 and 0.3 pens, while the one at left combined pen and pencil work.

My other favourite pen is the purpose-made art pen – the best-known being made by Rotring – with either sketching or fine/medium writing nibs. The nib is of the writing variety, and the ink is normally supplied in disposable cartridges containing non-waterproof ink. You can also get refillable cartridges and use waterproof ink, but I find this tends to clog up if the pen is not used frequently. This is a lovely pen to use and gives a fine delicate line full of feeling and expression.

A FEW TIPS ON BUYING AND USING PENS

- Try different types of pencils and pens, make your choice, then stick to it. Choose something that will give you the types of line you are after.
- Try not to keep chopping and changing to get too many gimmicky results.
- Once you have made a choice of pen, practise. You should find that you can achieve all you need to by using even basic pencils and pens to their full potential.

WATERCOLOUR MATERIALS

The materials included here are the ones I am most comfortable with, and have evolved over many years. Stick with the ones you like and learn to understand their effects.

Paints

People often attend my courses with tins of half-pan blocks of paint, but without any prior knowledge of what the paints or colours are, yet expect to produce a good painting.

Although you don't need to have gold-plated materials, there are a few things that you should invest in that will help – the first thing is to use well-known brand paints. For most of my painting life I have used Winsor & Newton, but I also have other known makes and find some good, others not; experiment, then stick to the devil you know.

All my paints are 6ml or 14ml tubes squeezed into compartments of my palette. Artist-quality, or artists' paints use pure pigments, whereas student-quality paints use some chemical substitutes. Artists' colours are more intense and go a lot further, but can lead the novice to using intense mixes and can create more opaque results. Good-quality students' paints are worth having nowadays – I use them all the time for demonstration purposes and even for finished paintings, and I would have no hesitation in recommending them for general use.

I have travelling boxes with half-pans but find that, although this type of paint is very suitable for more detailed work, I cannot get sufficient pigment from the blocks of colour to give me nice large washes. Timing is everything in watercolour, and often you need to mix another colour as quickly as possible before the previous colour you have put down dries on the paper.

I use a palette for painting indoors but have a travelling box which holds paint tube colours that I can take out. This travel box contains a mix of both student- and artist-quality paints. Once the paints have been squeezed into the palettes, they remain in those positions and can then be added to when the colours start to run out.

WORKING SELECTION

The order in which the colours are laid out is very important. If you can get into the habit of laying them out the same way each time, it will make life an awful lot easier, as you hardly need to look to know where your colours are.

The colours that I use for all types of landscape painting – at home, outside and when working abroad – are as follows, laid out in the order on the right, with the most transparent colour first for each of the primaries: ultramarine – the first blue; alizarin crimson – the first red; raw sienna – the first yellow; and burnt sienna.

If the need arises I will very occasionally add another colour to my palette – but only very occasionally for a special reason or mix. There are no greens, no Payne's grey and no umbers in my basic mixes.

The two end colours of the palette mixed together will give you the darkest colour that can be achieved. Over the years I have eliminated colours that lead to mud if mixed with other colours. Except for really bright sunny days, the palette for landscape relies on subtle, tonal shades, and this palette should give you these, but with the added bonus of knowing you have all the colours needed to achieve the bold statements when they arise.

Get to know the colours you intend to use, for what purpose they're intended, and what they will do. All dark colours should be translucent – a mix of ultramarine and burnt sienna will give you this quality, warmed or cooled off with the addition of other colours; the umbers and Payne's grey will soak into the paper and only produce flat and lifeless results.

Of course you can produce excellent results by varying your own palette based on the one that I use, but try your mixes first and look at the results before you decide.

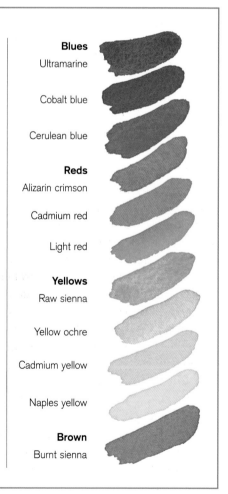

Blues
Ultramarine

Cobalt blue

Cerulean blue

Reds
Alizarin crimson

Cadmium red

Light red

Yellows
Raw sienna

Yellow ochre

Cadmium yellow

Naples yellow

Brown
Burnt sienna

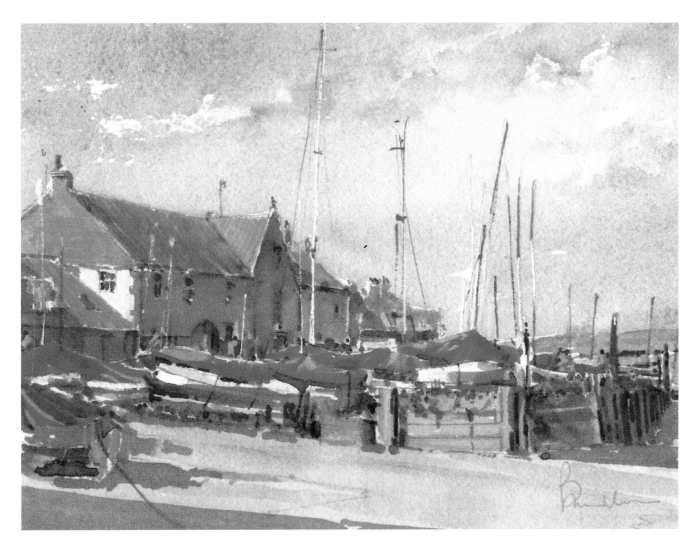

Burnham Overy with Boats. This painting uses the colours shown in the working selection on the opposite page.

Palettes

I was fortunate enough to be able to buy an extremely good plastic-based palette with a china palette feel, deep mixing wells and a slide-on lid. Although it is a bit cumbersome for quick outdoor painting trips, it is still the best I have come across, as it holds my paints laid out and ready for big washes. Unfortunately, this type is no longer made and you may have to search a bit to find a similar plastic palette on the market with deep mixing wells.

Whether you go for plastic or ceramic, do not buy a palette where you have to continually squeeze paint out because it has only small mixing wells, as this will inhibit the amount of wash you can make.

In addition to the larger palette I use a smaller travel-type one, where the paint can be squeezed out into decent mixing wells, and with its own hinged lid. I also have a pocket-size travel palette with combined water bottle and water holder, which is useful for on-the-spot sketches when I am travelling light.

Brushes

I am a firm believer that the most important piece of equipment you need to paint a good watercolour is the brush. As I have said before, watercolour is about timing, and you want to avoid using too many different brushes to do different things. The more you can work with a brush or a type of brush to do the job for you, the better you will get at painting and the better your marks will be, and you will paint with more confidence.

First and foremost, a good watercolour brush should have springiness, which is needed to be able to paint various marks with feeling and expression, flicks and washes. For me, that rules out mop brushes – the pine wood-handled variety with wire around the ferrule.

A good watercolour brush should have a big water-holding capacity, which is needed to put on a good flat

BRUSH SIZES

Although I do not use each one for every painting, I have a varied selection of sable brushes; you really only need the following sizes for landscape work, depending on the size of painting you would normally do:

Nos. 16 or 14; No. 10; No. 6; No. 4; No. 2 sable rigger

It is also good to keep a selection of older brushes or synthetic ones for applying masking fluid or gouache if used in your work, and for lifting off paint from areas (see Coastal village project, page 94).

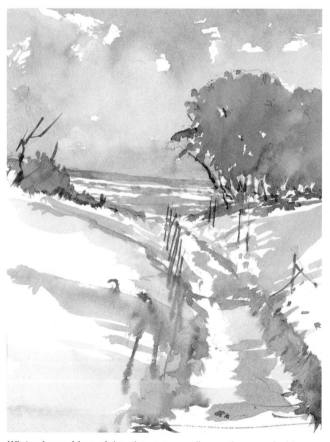

Winter Lane. Most of the picture area relies on the use of white paper to depict snow, with the shadows creating contours.

wash – and that rules out synthetic brushes and narrows the field right down to sable… and a round brush at that!

I know that sables are more expensive than the equivalent synthetic types, but there is no doubt as to which type of brush is the better – and, with care, a sable brush will also last a lot longer and will pay for itself by the savings you make from not buying inferior brushes.

Sables have excellent paint-carrying capacities, so you can apply washes in one sweep of the brush. Most of my standard-size watercolours are done with a No. 14 sable and finished off with a rigger. Sometimes, depending upon the painting I am doing, I will use a smaller sable brush as well.

Round brushes can be used in a more expressive way than anything else, so take time to find out how to use them to their full potential – they can make every mark you need.

PAPER

I so often see paintings not living up to expectations because of the poor selection of 'paper for purpose' – you must select the right type of paper to enable you to achieve your best work, and you will not progress or achieve the best results until you paint on proper watercolour paper. The paper surface can be the making of that elusive masterpiece if you are prepared to give it a go. Accept the challenge, and paint swiftly and with confidence.

Types and uses

Papers differ in the way they accept water, which either floats across the more slippery surfaces or sinks into the more absorbent ones like on blotting paper. If you are the type of artist who constantly wants to lift out paint, using an absorbent paper surface can only make life difficult.

Some papers are white, some are creamy in colour, and the surface textures differ. I am a strong believer in using a paper you like the look and feel of, as watercolour paper is very tactile, and nothing gives greater pleasure than to paint on a surface that you really like. Try as many types as you can, then make your selection. The differences in paper can be very subtle, as there are so many papers on the market nowadays, so be patient till you find one you prefer.

Better papers tend to be one-sided, with the rougher side being the correct side to use or, more often than not, the side on which you can read the watermark.

Papers come in three grades: hot-pressed or HOT, not hot-pressed (cold-pressed or NOT) and rough. There is a lot to be said for each type of paper, but if you want to paint mostly landscapes in watercolour, use the NOT surface type for most

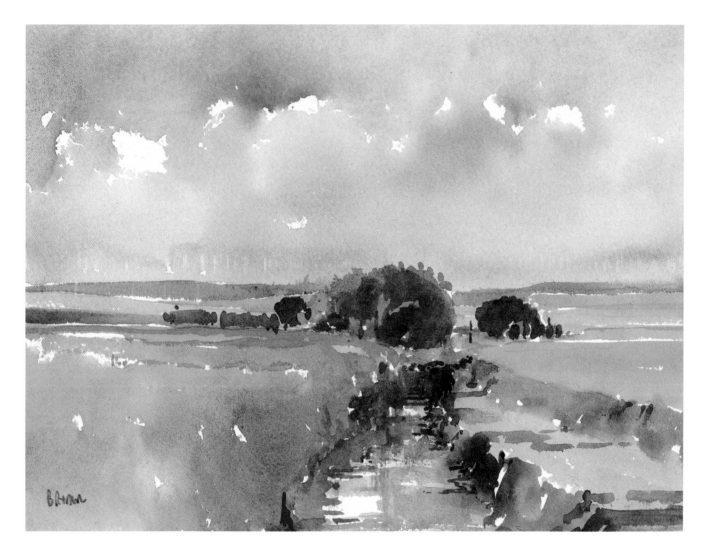

Summer Fields. This simple, understated watercolour sketch was created with a limited palette of colours.

of your work, as this is the most versatile and is able to take more different techniques than the others. The range is so diverse and everyone has their own opinions, but after many years I have opted for 75 per cent of my landscape work being done on Saunders Waterford NOT 410gsm (200lb).

Outdoors I normally use a block of paper in a hardcover book, usually an A4 or A3 or equivalent sizes, as some manufacturers of hardback pads seem to have their own special sizes. Indoors I normally use paper stretched on a board, and will also use this outdoors for more serious work.

For drawing and sketching purposes I either use a hardback book with medium-weight cartridge paper when I go out, or a spiral-bound book with the same quality paper, which I can tear off indoors.

For drawing, I prefer a paper that has a medium grip. The smooth surface is fine for pen, but I don't like the mark the pencil makes. The heavy weight is just too bumpy for pencil work and will not give you a fine unbroken pen line. Again, it is worth experimenting with your drawing paper till you find what suits your work.

Stretching paper

To stretch paper or not? This question comes up time and time again. Some professional artists never stretch their paper, as they maintain that wetting the surface removes all the size that manufacturers treat the paper with, while others always stretch the paper before working on it.

I feel you should make life easier for yourself when painting. I do not want paper cockling all over the place when trying to paint, as I want a nice flat surface to the finished painting, so unless I am working on pads or books outdoors or doing small sketchy work indoors, I always stretch my paper first. Over the years I have tried various ways to stretch my paper and I now use a reasonably quick and simple method, described overleaf, which seems to succeed most, if not all of the time.

STRETCHING PAPER

You will need:

Sheet of watercolour paper
Board
Roll of 50mm (2in) gummed
 brown tape, available from
 stationers or art shops

Sponge; small washing-up
 sponges can be obtained at
 supermarkets
Access to a kitchen sink and
 a flat layout surface
Sheet of kitchen roll

- Hold the sheet of paper under a cold running tap in the sink for about two minutes until all the surface is soaked.

- Turn the sheet over and do the same on the reverse side. Turn off the tap and hold the sheet by the corner over the sink until the excess water drains off and only drips come off the paper.

- Lay the sheet of paper on the board with the side to be painted on face up, then wipe the edges of the paper with the kitchen roll about four or five times until touch-dry, to obtain good adhesion of the tape.

- Tear or cut a length of the gummed tape and wipe the sticky side with a damp sponge (not over-wet). The tape should look and feel quite tacky when you have done this.

- Tape down one side, applying a good pressure to the tape on the paper and board – half the tape should be over the paper and half on the board; ensure it is firmly pressed down, particularly at the join between the two. This is to exclude all possibilities of air getting around the paper edges.

- Repeat on all sides and dry on a flat surface. The drying time will depend on the temperature, but I stretch four or five sheets at a time and allow them to dry overnight.

- To stretch and lay each sheet flat for drying will take no longer than 5–10 minutes each. I think it worth the time and trouble to do this as all will be ready for your painting, and you will have a lovely flat, bouncy surface to paint on.

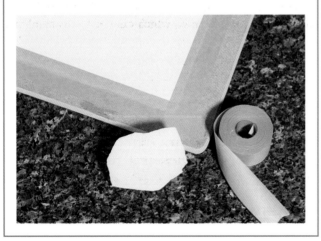

Watercolour boards

I like a fairly tight stretched paper to work on, a surface like a drum that gives you a bounce when you draw or paint on it, something akin to a stretched oil canvas, which gives you the feeling that the brush just floats over the surface.

When the paper is stretched it applies an awful lot of pressure on the tape and backing board, and if the board is of insufficient thickness it will warp, not from the water content within the paper but from the tension caused by the stretching process. A 10mm (⅜in) MDF (medium density fibreboard) board works very well and is not too heavy. Do not use three-core plywood or any other board under 10mm (⅜in) thick unless you paint only small paintings.

Boards can be obtained quite inexpensively at DIY shops, and normally come in full sheets of 2.4 x 1.8m (8 x 6ft) or half sheets of 1.2 x 0.9m (4 x 3ft); cut into four, a half sheet will give you four boards to work on of 600 x 450mm (24 x 18in) without any waste, and will also provide just the right size to take a half-imperial sheet of watercolour paper of 560 x 380mm (22 x 15in) without being cut up any more. If you want to paint on larger size sheets of paper, it is perhaps best to use 12mm (½in) MDF to cope with the larger board size.

OTHER MATERIALS

I am very happy, at times, to use other media to create effects. My hero, JMW Turner, would use whatever he thought appropriate to create the atmospheres and effects he was seeking. So whatever is good enough for him…

Below are the only extra materials I use, and only the kitchen paper is used all the time. If you can paint with this equipment and no further added materials, you will start to learn to paint better and get more successful results.

White gouache

I use this to create highlights and, mixed with a small amount of watercolour, it can give some nice effects (see Coastal village, page 94). However, be aware that the colours made will become dull, and you may be back at square one with unwanted areas of opaque colour. Use the gouache at the end of the painting, otherwise you will end up making all your colours cloudy.

Gouache is much thicker than normal watercolours and needs to be thinned before use. Try using a rigger brush for thin white lines or, thinly mixed, with watercolours.

Pastels

I use Unison or Winsor & Newton soft pastels (see Snow scene, page 72), but do not get too fussed about the make.

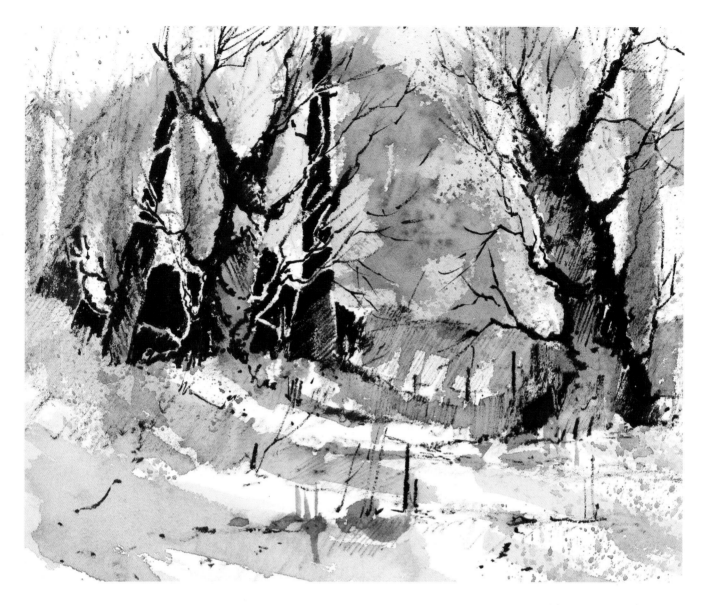

Winter Trees. The pen used here was a brush pen, which I used in combination with watercolour washes.

Some people see using pastels as a way of retrieving a watercolour, but this will only lead to badly executed watercolours if you end up thinking you can cover up your mistakes.

Pastels must be applied with thought and care, and should be used as a support to your watercolour, working with it. You will only get the painting that you want with the right balance between the two media – remember, this is a watercolour with some pastel overlay, not a mixed media abstract.

The best method of using pastels over a watercolour base is to try to avoid using a complementary pastel colour to the watercolour you are painting over – in other words, if it's blue underneath, put a blue pastel over it, not another colour. It is worth having a few tints of the same colours that are in your watercolour palette to use in this way.

Brush pen

I have taken to using a brush pen to create effects with some of my pen and wash paintings (see Buildings and water, page 52). This is a pen with a disposable cartridge, but instead of having a nib or a fibre point, it has a nylon brush tip. This enables you to make free, bold marks, but although when used with restraint it is delightful, you can get carried away and end up with a heavy black blob of a painting.

There are also disposable brush pens on the market with different coloured inks, and on occasions I have used a grey brush pen made by Pentel, which can work well combined with a pencil drawing.

KITCHEN PAPER

We have already mentioned kitchen paper, and although you may feel it is not that important, I think it is essential that you have some to hand at all times. In days gone by, rags were used, but now the kitchen roll has taken over. A sheet of good-quality kitchen paper is very absorbent, and when screwed up and used damp, it forms an essential part of painting materials.

WORKING OUTDOORS

So you want to paint from the landscape, outdoors, *en plein air*. I think the worst thing you can do is load yourself up with so much junk you are defeated before you begin: just try hiking a bag, easel, board and seat across open country-side. Obviously, if you only intend to produce sketches in a book, a bag or large pockets will do. If you want to put some colour down, it still helps to plan what you intend to do.

'Oh, I will take it all, just in case': indecision means you will do nothing.

No time for colours? Just take a couple of pencils and pens and a sketchbook, and note down colours. A photo may also help just in case you spot that special scene.

Perhaps you have a bit more time and a few colours would be nice: you have your pencils and pens, but this time take a watercolour pad instead. On these occasions I take my small travel watercolour set with me, which slips into my back pocket, so I am still travelling light. The travel

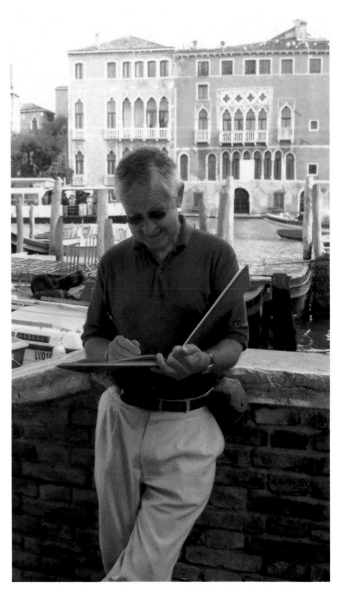

Making an impromptu stop. Always carry some form of sketchbook with you so you are prepared. If you haven't time to get out your paints, a pencil will do, and simply note down the colours for future reference.

Sketching in Venice. I often lead groups of students on drawing and painting tours in Italy. At a planned stop to record a popular landmark, I use my canvas art bag as a convenient seat, and rest my sketchbook comfortably in my lap.

set holds all the watercolours I may need, but in half-pan form, a small water bottle and brush. The brush supplied is somewhat small, not really for landscape people, so I take a small sable travel brush as well. This set-up is not for serious painting excursions, but I can usually get a sketchy water-colour down in a short space of time.

For a painting trip resulting in a proper watercolour, first things first: you need a bag. I have an old canvas bag with one large compartment to take most of my stuff, and a smaller bit to take pencils, pens and so on. The bag is suspended in a folding frame with a shoulder strap so I can easily carry it in its closed position or put it on the ground in its open posi-

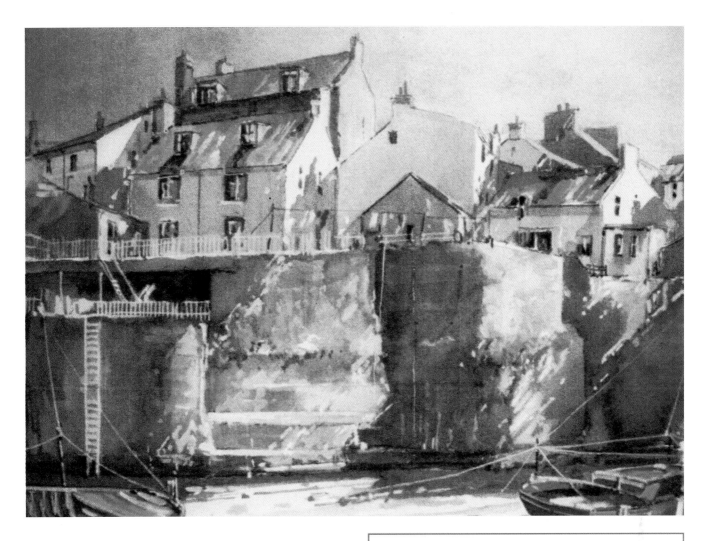

Light at Staithes. This is another view of one of my favourite spots for working outdoors (see pages 8 and 9).

tion, which then forms a seat. This is ideal and will save you taking a separate seat or stool. If you can't easily find such a bag, there is the backpack type with an integrated seat.

You will have noticed – no easel!

Unless I am working to a larger size, or I am out on a really serious painting trip when I take stretched paper on a board, I prefer to work with the pad on my lap. An easel is a serious piece of cumbersome equipment, however lightweight the manufacturer claims it is – and have you ever seen people carry one with their bag, pads, etc without a problem?

However, if you ever do need an easel outdoors ensure you paint near to your car, or whatever, so you can make a second trip to collect it. Aluminium ones are easy to set up and fold, but may not be too stable on rough ground or in windy conditions.

EQUIPMENT FOR OUTSIDE TRIPS

Into my bag go the following bits and pieces:

- Plastic water pot with non-spill top and tight-fitting rubber lid.
- Medium-size mineral water bottle, filled with water, with special drinking spout.
- Paints in travel palette.
- Brushes in brush roll to prevent damage.
- Pre-sharpened pencils with putty rubber.
- Pens.
- Hat that can be folded up to put in the bag.
- Digital camera: when there is a lack of time, I do a drawing plus a wash of colour and take a photo or two. Back in the studio I print the photo and make a larger black-and-white copy to show the tones, and use both of these, plus my watercolour sketch, to produce the final painting.
- Sheets of kitchen roll – invaluable for drying brushes, wiping back applied paint, wrapping up old banana skins, protection, etc.
- A thermos flask and a paperback book for break time.

Drawing techniques

DRAWING FOR DRAWING

The three most important elements of watercolour painting are drawing, drawing and drawing. Yes, I have said this already, but now let's see what I actually mean.

Although I spent most of my working life in architects' offices – 'Oh, you must be able to draw, then' – I have always tried to emulate the really good draughtsmen in the office. The sketches they did were always magic to me, and I practised and drew for hours to copy their way of making a mark with a lead pencil. No, I could not always draw, and I am still learning. Everyone, if they want to succeed with their painting, should spend an equivalent amount of time drawing.

We are not all gifted with the ability to draw, but it can be taught, and practice will improve your technique. If you are not prepared to practise your drawing, the watercolours you produce will remain in an unsatisfactory state forever.

Everyone has their limitations in whatever field they choose – even the greatest artists aspire to get better – so push your own expectations higher. This applies to drawing work. I hear 'I can't draw very well' so often, yet the same people hope to produce a masterpiece of a watercolour. Some also feel that they can produce such a painting without having any drawing skills at all. I think this is misguided.

What is important to learn?

There are as many drawing styles as there are painting styles, and the type of drawing that you do will influence your final painting. I never, when teaching, impose my style on others, but teach them to improve the art of drawing and painting to suit what they want.

First, it is useful to look at drawing for drawing's sake and see the marks you can make. To start with, try the exercise page opposite and remember: use a soft and sharp pencil; learn to use the point and the side of the lead; and draw assuredly and with confidence.

Now look at the marks and the texture; are they what you are after? Try the exercise again.

Consistency

One very good tip that I have used over the years for producing good drawing is to always shade or hatch each separate element of your drawing in the same way – consistently.

Although you should develop your own style and signature with your drawings, practise the technique of making the marks for shadows cast, for example, in one direction only. I normally use a diagonal stroke for this, which is different to the vertical stroke I might use for the shadow side of buildings, for instance. Once you get into this way of working, your planning has been done and you will not only be able to draw faster, but also better.

Try the following exercise: draw the cottages below with the light from opposite directions, and practise the marks and shadows you draw in one direction. Try using your pencil to create the drawing by applying light through to heavy pressure – to do this, do not take the pencil off the paper.

This is also a good exercise for creating textures, light and shade. The cottage shapes are drawn so that the pencil line is hardly seen, whilst the black marks are made by applying heavy pressure, all with the same soft and sharp pencil; I used an 8B for the exercise.

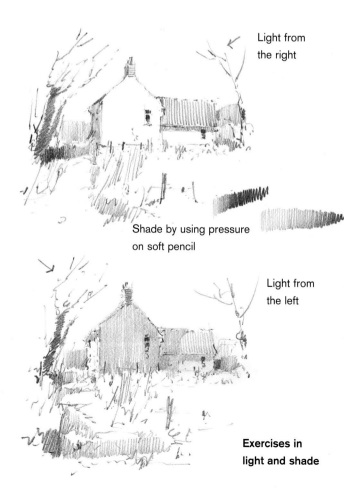

Light from the right

Shade by using pressure on soft pencil

Light from the left

Exercises in light and shade

EXERCISES FOR MAKING MARKS

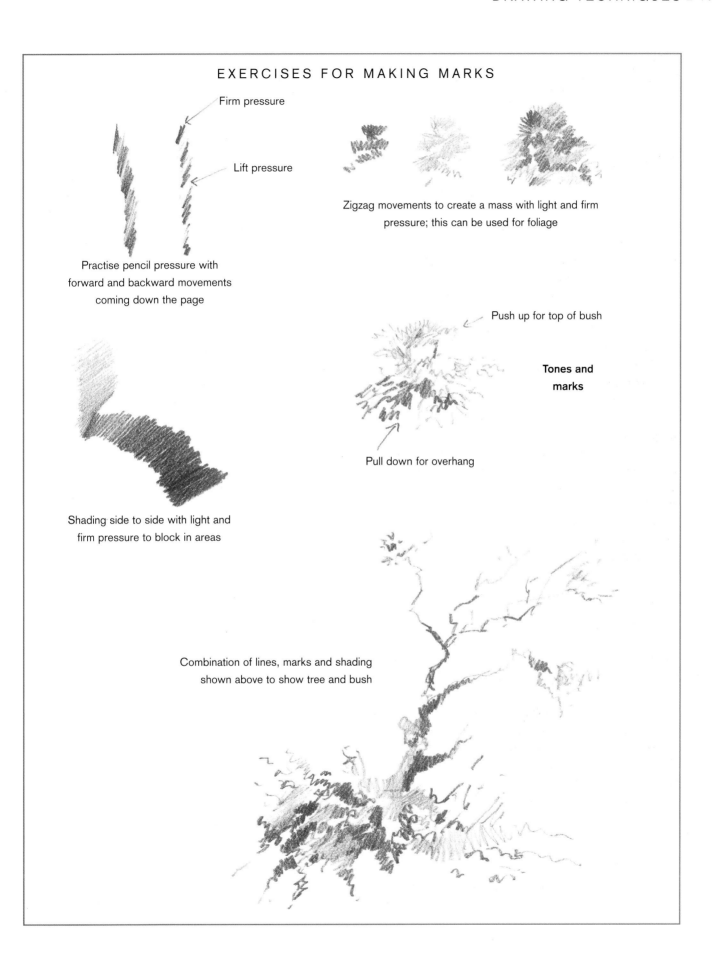

Firm pressure

Lift pressure

Practise pencil pressure with forward and backward movements coming down the page

Zigzag movements to create a mass with light and firm pressure; this can be used for foliage

Shading side to side with light and firm pressure to block in areas

Push up for top of bush

Tones and marks

Pull down for overhang

Combination of lines, marks and shading shown above to show tree and bush

DRAWING FOR WATERCOLOUR

Be observant and draw what you see with confidence. Remember that you are drawing for a watercolour painting, so many of the 'details' will be done with the paint – learn to leave out the intricacies at the drawing stage.

Pencil

When it comes to what type of drawing you should do for a watercolour, I find people get confused as to how much they should draw, how heavy or light the drawing should be, and even what should be drawn.

You should first ask yourself a question: 'Do I or don't I want my drawing to show through the finished painting?' This is a very personal thing that may vary from one painting to another, or you may have strong views that pencil lines should never show, or should always show.

My view is that I like the drawn line; in most of my watercolours you can see the pencil over a lot of the finished work. I sometimes redraw a pencil line after the paint has dried – now, there's a confession. The depth of marks in the picture below are sufficient to show through the paint.

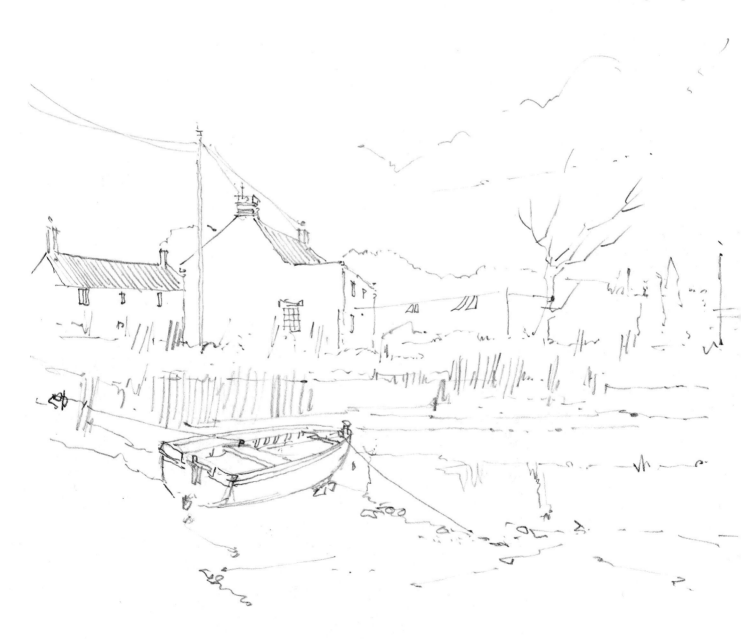

Line drawing. This is a typical drawing for watercolour – note the lack of detail at this stage.

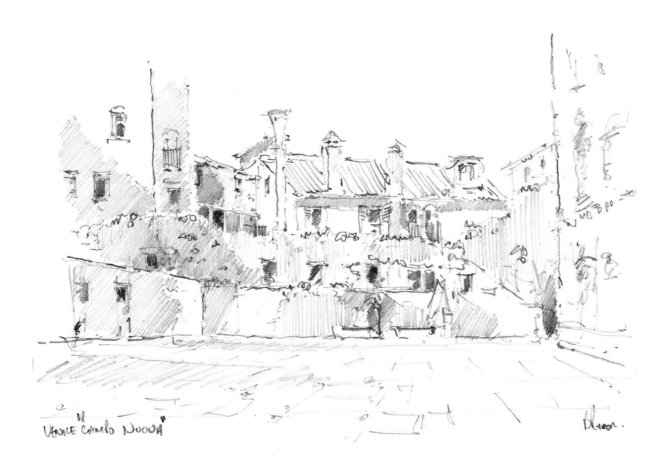

Venice Campo Nuova

Campo Nuovo, Venice.
This is a preliminary drawing
for the finished painting
shown on page 121.

Bintree Mill. This drawing
is far more worked up than
the one opposite; however,
the details are still not very
intricate.

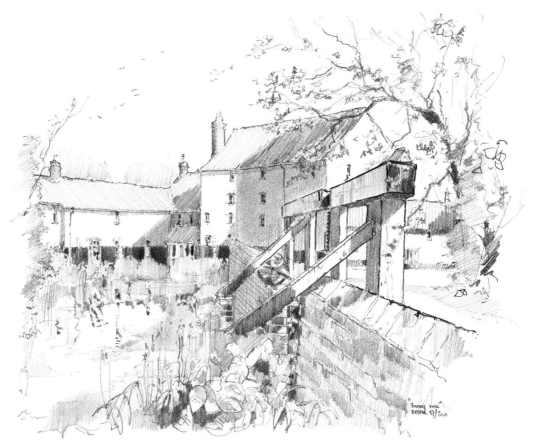

Pen

When drawing with a pen I use a fine pen first, followed by a pen that makes a heavier line, so the technique is different to using a pencil. When making pen and wash drawings, I never draw a pencil drawing first and go over it with a pen line, as this produces hard, stilted lines devoid of character and feeling.

Be bold and confident enough to draw straight off with a pen. The line will get better with practice. You will not be able to rub out, but you will soon come to realize that lines drawn incorrectly do not matter too much; your style will come through. I favour two approaches:

- Minimum line for maximum effect: you need to put the pen line in the right place.
- Lots of lines, with some of the right ones picked out with a heavier line. Your eye will actually pick out the correct line and ignore the wrong line.

More often than not, due to a shortage of time I draw with a pen outdoors and lay a light wash over it. For this I use the second approach, and back the painting up with a photo or two for colours and details I might not have picked up.

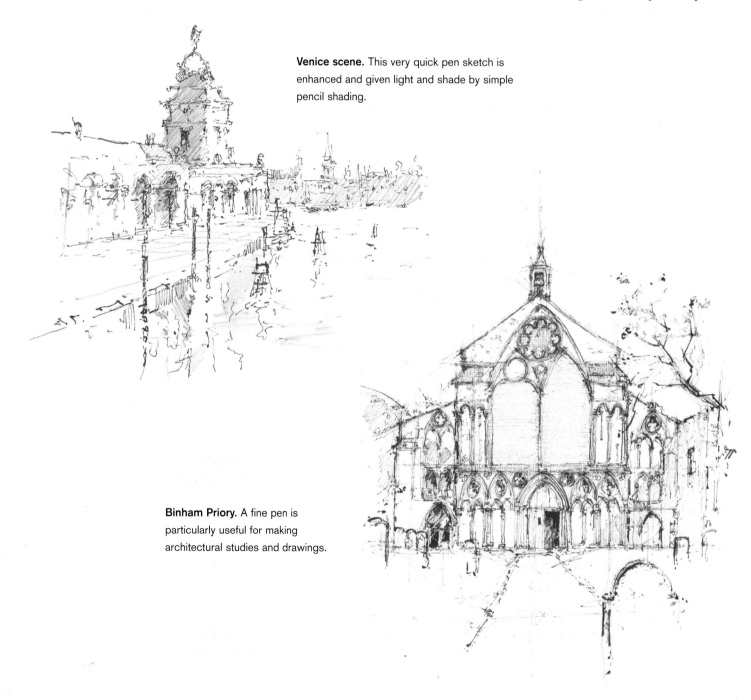

Venice scene. This very quick pen sketch is enhanced and given light and shade by simple pencil shading.

Binham Priory. A fine pen is particularly useful for making architectural studies and drawings.

COMPOSITION AND SIMPLE PERSPECTIVE

Be focused and observant, take your time and draw what you see; don't let a 'difficult' perspective or composition put you off if you think it would make a good painting.

Composition

Place an inexperienced artist in an area of countryside and ask that person to paint a picture. They may well move on, finding nothing worth painting, and if the area around them is unknown, they may spend the whole day looking for something and end up painting nothing. However, place a professional or experienced person in the same area, and they will turn around or look within that same place and produce a painting. Why?

Because any scene can be found and recognized as having good composition and its potential recognized. But what is good composition?

I think this is recognized through experience and practice; your final painting will tell you that. If it does not work, go out and try again – you will soon come to recognize good composition by the mistakes you make. By doing so, you are practising all the time, and good composition can automatically be achieved without trying.

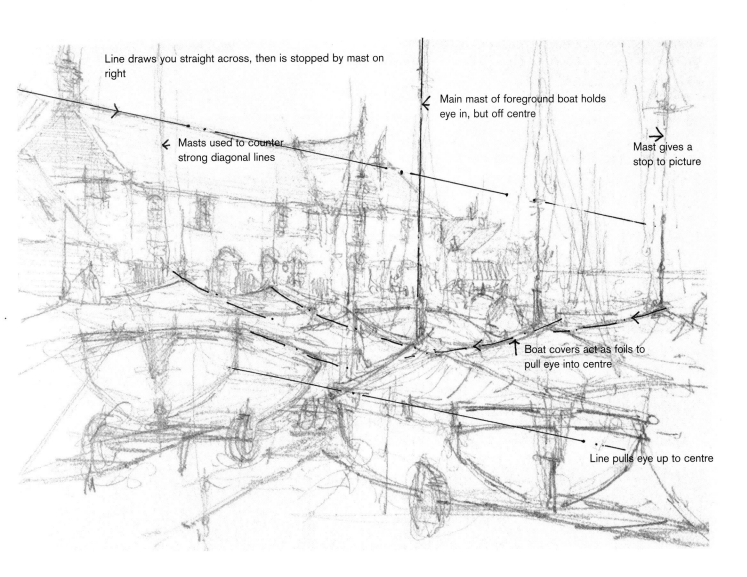

Line draws you straight across, then is stopped by mast on right

Masts used to counter strong diagonal lines

Main mast of foreground boat holds eye in, but off centre

Mast gives a stop to picture

Boat covers act as foils to pull eye into centre

Line pulls eye up to centre

Burnham Overy. Even if you're not dealing with a complex perspective or composition, making notes on your sketches of a scene is very helpful. The ones added to these drawings show some of the points to bear in mind.

Perspective

Perspective is yet another stand-alone subject, and I could devote a whole book to it; here I will try to explain it simply, without a lot of notes and diagrams, which could end up confusing you. You don't need to be 100 per cent accurate, as this can lead to mechanical illustration, but some knowledge and a few basic principles that give you a convincing drawing will help your final painting.

The most important thing to remember is your eye level in relation to the subject you are drawing or painting. You can draw this as a horizontal line; always refer to it as your eye line – it will never vary on the subject you draw at the time.

For example, providing the ground level is flat, the eye line will be approximately a third up the wall of a typical two-storey building if you are standing up, and obviously

lower when you are seated. So never sit down once you have started your drawing when standing up, and vice versa.

Any horizontal lines above your head go down to the eye line, and those below your head go up to the eye line. Vertical lines are always vertical.

Where these lines hit the eye line on the front plane of the subject is called vanishing point 1 (VP 1), and on the side plane, vanishing point 2 (VP 2). This is known as two-point perspective and is the only type to concern you here.

If you are confused already, look at the drawings below and opposite. The angles you draw for these lines are taken from your assumption of what you see.

Hold a pencil at arm's length against the angle – a roof gutter line, for example – and transfer that to your drawing. Once the basic house shape is drawn, everything else will follow this principle.

With practice, and learning to look at each subject you tackle and understand the perspective, you can concentrate on your drawing skills, worry less about the perspective and paint and draw with confidence.

Simple eye line. This sketch shows how the angles in the scene converge upon the vanishing point 1 (VP 1) on an easily found eye line.

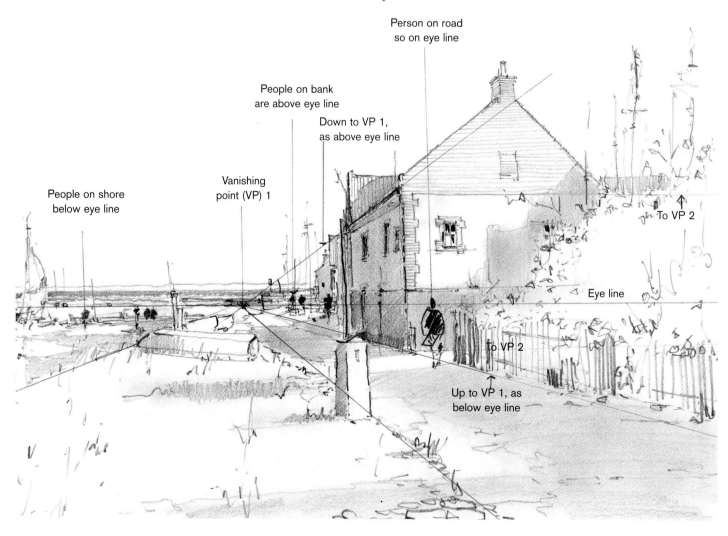

Person on road
so on eye line

People on bank
are above eye line

Down to VP 1,
as above eye line

Vanishing
point (VP) 1

People on shore
below eye line

To VP 2

Eye line

To VP 2

Up to VP 1, as
below eye line

More complex eye lines. In the sketch right and study below, note that the eye line is not at an easily found shoreline, as in the example opposite. The principles for finding and marking VP 1 and indicating VP 2 are exactly the same, however – you just have to take time to find and mentally or physically mark the eye line as your first point of reference for the scene.

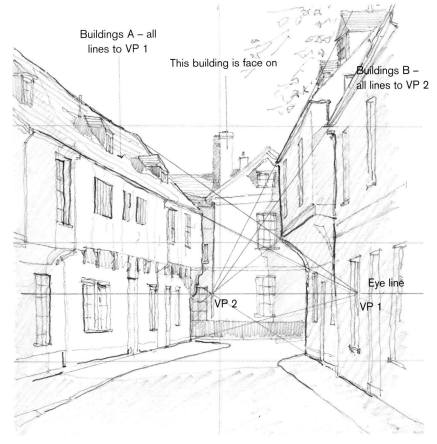

Buildings A – all lines to VP 1

This building is face on

Buildings B – all lines to VP 2

Eye line

VP 2

VP 1

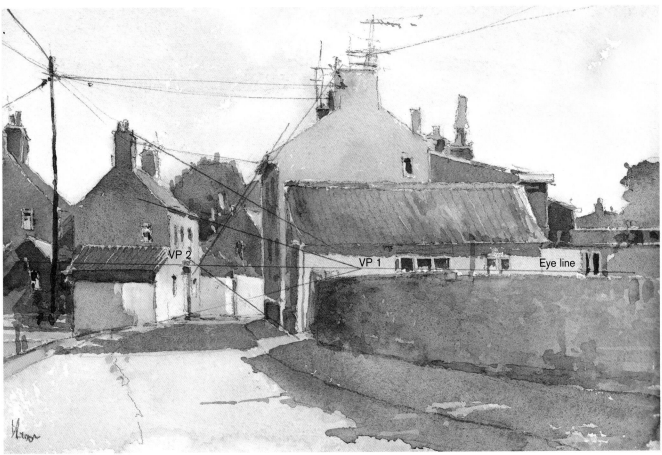

VP 2

VP 1

Eye line

Watercolour techniques

This chapter contains all the watercolour painting techniques you need to paint with confidence. I tend not to set about a painting using a specific technique, but let a technique come out of the painting I am doing because the atmosphere that I am trying to create warrants its use.

Thames Barges – After Edward Seago. As with the paintings on page 125, this is an attempt to use watercolour washes for a scene based on an oil painting – the aim is not duplication, but to capture the feel of the original.

BASIC WASHES

Basically, there are two main watercolour wash techniques: applying wet paint to dry paper (wet-on-dry), and applying wet paint to wet paper (wet-in-wet). Any other techniques are really only variations on these, but these variations can be used to great effect once you are familiar with the main two. In particular, painting on to damp or drying paper can produce some pretty disastrous results unless the medium is understood to some degree.

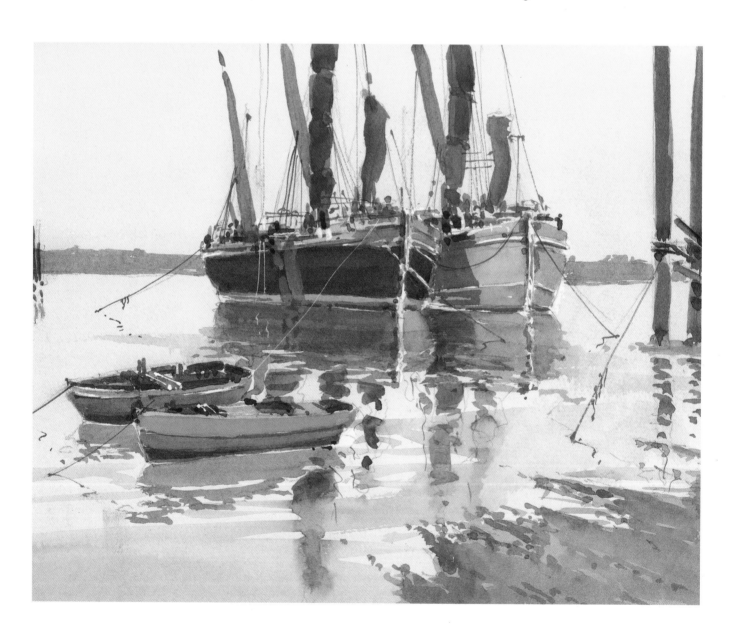

WET-ON-DRY

This is the basic starting place for watercolour: mix the colour you want to use, then apply it to a drawing, or, to be exact, colour in a drawing you have made.

1 Colour applied to a drawing.
2 Second colour painted over the first when this is dry. Keep layers to three at most, to avoid a muddy result.

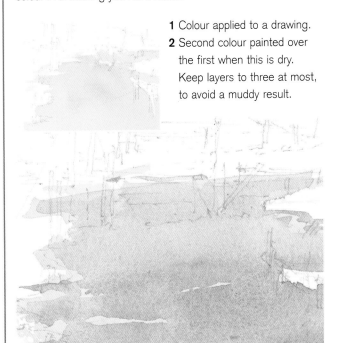

3 Put two or even three colours on to paper, letting the paper mix the edges for you. Remember, easy does it: let the paper do the mixing and let the brush do the work for you – float it over the surface, don't push.

When painting skies, because you are using a light wash, aim to hit the right colour first time; try to avoid painting back into skies, just cross your fingers and hope for the best. However experienced you may be, some skies will be better than others, but that's watercolour for you! However, constant practice will get better results – don't fiddle, don't paint back into the wash, be assured and paint with confidence.

4 With a wall, by contrast, you have the chance to overlay again because the subject is more opaque, unlike a light translucent sky, so keep the pigments light for a better result.

Another way to mix colour is to apply a colour on to dry paper, raw sienna for example, and leave it to dry. Then apply a wash of alizarin crimson over the sienna wash, and an orange colour will emerge. Finally, lay a wash of ultramarine on this orange... and a grey sky will result: depending upon the intensity of the individual colours used, the sky will have a bias towards the most intense colour.

TIPS

• *Watercolour will dry about 30 per cent lighter than the colour you put down on your paper.*

• *Always mix or run together colours on the paper. You are not using white to lighten your colours, so the white base paper colour is theoretically your added white to lighten colour.*

• *The less paint pigment you add the lighter the final colour, whereas more pigment in the mix will hide the paper and a darker result will be seen. This last point may seem obvious in the extreme, but you would be surprised how easily this can be forgotten once you have a paintbrush in your hand.*

WET-IN-WET

Now try the exercises on page 27 again, this time painting the colours on to wet paper. This is where stretching paper comes into its own, because you can wet the surface and drop colours on to the paper without a cockle in sight.

Mix the colours you want to use before you start. Make sure the angle of the board is at a slope towards you, and brush clean water to cover the area you want to paint on – and wait.

When the gloss goes off the paper, the water is evaporating and soaking into the paper, which appears to have an eggshell finish. Now float the pigments on to the surface – with practice, timing and confidence, you will get the result you are after.

The best results can be obtained by planning what result you are aiming for, and by never going back over the areas into which you have already dropped colours.

Controlling wet-in-wet. Although much of the attraction of working wet-in-wet is the paint's unpredictability, you can help areas to dry quickly by blotting surplus water with a piece of kitchen roll or tissue.

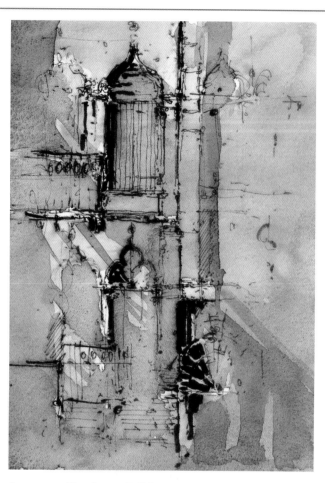

ABOVE LEFT: Sky; ABOVE: Building

To see how wet-in-wet works to begin with, paint a simple sky scene to start with; the principle in the picture above is exactly the same, but the pen lines produce a structure for the washes.

Remember also that you have already put clean water on the paper and are now applying pigment mixed with even more water, so the results will be lighter in tone when all the water has dried than if you had applied exactly the same mix on to dry paper – this can be experimented with on scrap paper before you commit yourself to working on a painting.

TIP

Don't wet any more than the area of paper you wish to cover; the paint will stop at the dry area and create an edge.

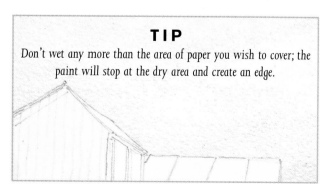

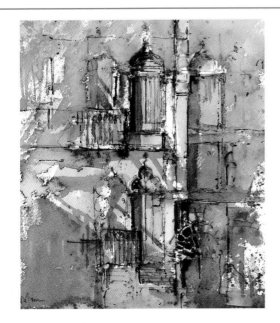

Venetian Balconies. This shows a finished study of wet-in-wet and splatter techniques (see opposite and page 27).

Cottage. This simple study was painted as an example to show wet-in-wet: I first wetted the paper and brushed in the first colours, then added salt to the colours for texture before allowing everything to dry. I brushed off the dry salt and painted further washes, where the edges mixed on the paper, and again let it all dry before I finally painted in the details.

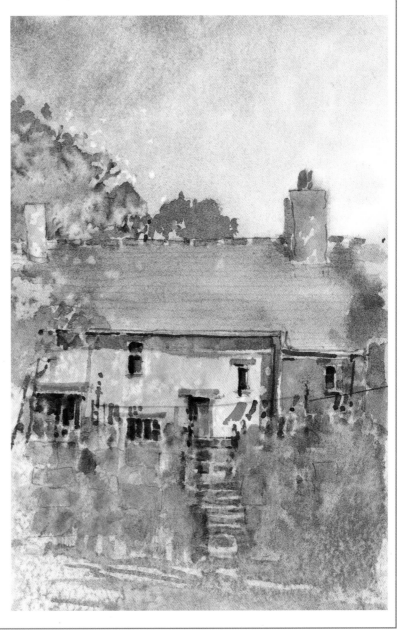

LIGHT AND SHADE

This is one of the sections where painting with confidence really comes into its own – and it is applicable to all painting and drawing media as well as watercolours and pen and wash work. All too often I have seen good watercolours that could do with some more light in them – this is usually due to a lack of sufficient contrast and special effects with shadows – the paintings fall short of that extra something that makes them stand out in a crowd. What is needed here is a confident brush, full of colour and shadow up against the lightest parts of the painting, to make everything 'zing'.

Shadows

Getting the exact shadow colour to suit your images may appear to be tricky, but here are a few pointers to help you.

First, you need to see through the shadow to the colour beneath, so a translucent colour is a must – the most translucent blue is ultramarine, red is alizarin crimson and yellow is raw sienna. Next, give some thought to the depth of shadow colour. Trial and error have led to the formula for shadow mixes, below, based on the colour wheel.

Shadows falling across grass or a roof, for example, are a darker and cooler version of the base colour. Mix red,

FORMULA FOR SPARKLING LIGHT AND CONVINCING SHADE

The first thing to think about to achieve sparkling light and convincing shade is painting your watercolours in stages, using the traditional technique of layering. I have used the following procedure in the step-by-step projects:

STAGE 1 is the initial drawing and any light toning down of the whole sheet of paper

STAGE 2 is painting the basic light washes

STAGE 3 is establishing the darker colours and/or the shadow areas

STAGE 4 is painting in the dark marks and details

STAGE 5 is adding the cast shadows

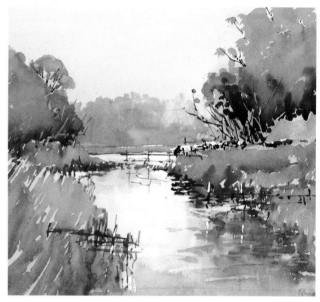

The moving grass and trees were painted in a pale green wash, with darker layers thrown into light by the intense darker greens and the suggestion of cows coming down to drink. The pale wash of the flooded marsh helps to create the light and shade effect.

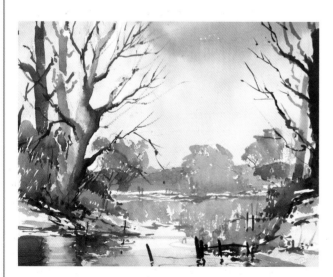

The tonal quality of colours on the trees in this winter scene creates the light and shade. The shade is mainly indicated by the depth of colour in the tree shapes, which cast fairly limited shadows to show up against the pale background.

That's it – three layers of colour, maximum (and possibly a light tonal wash beforehand), that are just right to achieve a vibrant, non-muddy watercolour painting where light and shade are paramount. Keep all your colours pure and let the white of the paper show through – and don't be afraid to paint the shadows dark. At all costs resist the temptation to paint back into your work: plan ahead, think hard and try to get it right to begin with – then paint quickly and confidently. With practice this will work.

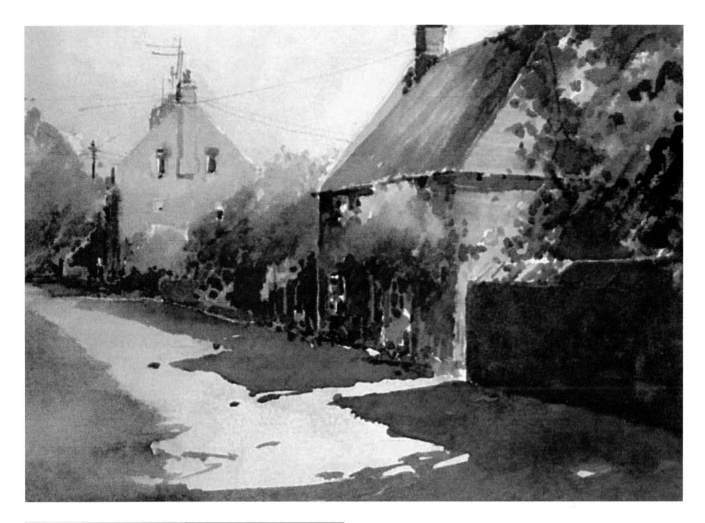

Village Street. I overemphasized the purple shadow cast from the wall and cottages to suggest the intense sunlight in this painting. The light is picked up from the top edge of the wall to help this, and the shadow colours contain some of the colours in the cottages to achieve the effect.

PAINTING DARKS

In a way this is the same problem as painting shadows. Many people are afraid of painting in the dark areas, often making them greyish in tone by holding back; and then they wonder why their paintings lack impact.

Darks should be translucent, not thick and opaque, and you should aim to paint using darker colours than you would first choose. For an example of a deep, but not opaque, dark, add burnt sienna to ultramarine; keep the mix on the blue side, and the translucency of the mix will stop it looking like a mud pie. You should still be able to see the paper through the mix, and if the lights are light enough you should never have to make the dark mix too heavy.

blue and yellow to make a dark translucent colour, add a bit more blue to cool the colour and then a bit of the base colour to darken the mix. Many shadows are purple, which can be made up from red and blue, and you can leave out the yellow for brighter paintings. Paint a tone darker than you would first think of, and never, ever go back over it.

For soft-edged shadows, apply paint when the base colour is still wet, and let the first layer dry completely for hard-edged shadows. Use a large, well-loaded brush and paint the shadow areas swiftly and confidently: don't touch the shadows again or fiddle with them. This will take practice and mistakes, but you will be able to recognize the right colour and tone, even when the mix is on the palette.

ADDING DETAIL

Adding detail is not usually as difficult as some other parts of working in watercolour, except that detail can be over-done and the painting made over-complicated.

The cardinal rule is to leave elements of your painting underdone, or to say the same thing in another way – do not paint everything; learn what to leave out. If you let the viewers, by careful suggestion made by your washes or marks, make up their own minds as to exactly what they are looking at, the painting will always retain mystique and interest.

I use smaller sable brushes to add details, with the addition of a sable rigger brush. Once again, the trick is to practise and work on being able to apply even thin or tiny marks with confidence – combine this with not trying to over-complicate a painting, and you should see some success.

Beach huts. Using a small brush to add the fine details (see Beach huts project, page 46).

Light or white detail

In many paintings you may need to add some small light or white marks, which are not possible to achieve by just leaving the paper white while painting normally.

Some artists successfully use masking fluid to obtain light marks and highlights in their work. However, the marks obtained using this method can be harsh and mechanical, and it is always a problem to know at exactly what stage to remove the fluid. Instead, I use white gouache to achieve the result I am looking for.

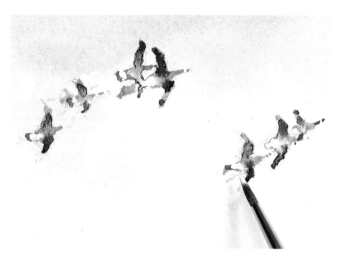

Geese in flight. Adding the white highlights on the undersides of the wings and bodies with gouache.

However, when using gouache there are a few things to consider when adding detail:

- White gouache is much thicker and more opaque than watercolour, and will produce a dull effect unless used direct from the tube without any additional water.
- Do not use white gouache until the very end of a painting.
- Always be very sparing as to the amount that you use. Make the brushmarks suggest the detail, as it is better to use tonal depth of colour rather than paint every last bit.
- Do not paint large areas with colour mixed with gouache – your painting will end up looking like a mixed-media picture, but one where the two mediums used do not go together successfully.
- Pen and wash and watercolour seem to work with pastel, but watercolour and gouache and pastel do not.

FIGURES IN A LANDSCAPE

Never – unless you are very good at doing it, and even Turner wasn't – show people within a landscape unless they form a major part of the view or they are represented by suggestions or marks made in such a way to suggest they are people. If you do feel that people shown in your landscape would give it scale, don't show their feet, as, like showing the base of a tree trunk as a flat line, doing so makes the figures too stilted.

Binham Priory. This is the same scene shown on page 22, with the details added in paint over the original drawing.

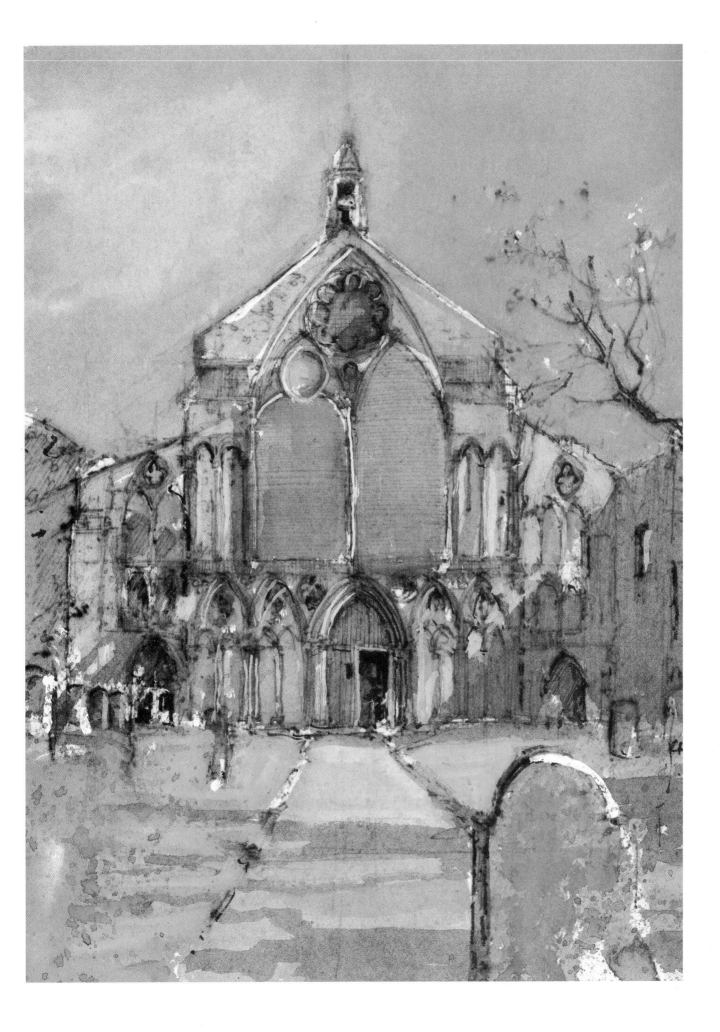

OTHER TECHNIQUES

A list of all types of watercolour techniques would be extensive; in this section I intend to cover three of the basic alternative techniques that I use in my watercolours.

Resist

The idea of resist techniques is to actually stop watercolour from drying on the surface of the paper and thus prevent it leaving a mark or colour. Rubbing wax, commonly the end of a candle, on the surface of the paper prior to applying colours will stop the adhesion of the paint, and give a broken drybrush type of finish.

The paper that you use will obviously have an effect on the result – if it is too light, it will not stand up to the application of the wax layer.

Spattering

For spattering techniques you need to use a stiff brush – a bristle oil paintbrush or an old toothbrush are well suited.

Make up the colour mix required, dip your chosen brush into the mix and then flick the paint-loaded end over the

painting to obtain the spattering effect. It may be necessary to mask off any areas of the painting that need to be protected with newspaper – the paint can go everywhere if you are not careful.

Try spattering into wet paint, then damp paint, and then on to dry paint for different results.

Granulation

One technique that will actually happen of its own accord, without you needing to do a thing, is granulation, which occurs when the addition of water separates the paint pigment from the gum arabic that holds it together. This is the case with some pigments more than others; ultramarine, for example, is notorious for granulating.

If you do want this result, just paint normally with your painting tilted on a slight slope towards you; be sure to use ultramarine, in a sky for instance, and a paper with a textured surface, and hey presto!

If you do not want this to happen, paint vertically on an easel, which lets the wash run down faster, leaving no chance for the separated pigment to get left behind; and use a smooth-textured paper.

LEFT: **Heavy spattering.** Using a darker colour for spattering than the washes already applied makes for a dramatic effect; use this with care, and don't overdo it.

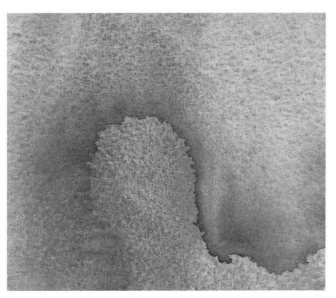

Light spattering. Here, spattering using the same colour as the shadows helps to produce a more subtle textural effect.

Granulation. This wash of ultramarine shows how the pigment can granulate on textured paper.

Colour Mixing

'How is it that with that mucky-looking palette you are using you can mix the colours that you are after, yet with my clean palette I produce mud?'

There are a few simple parts to the answer: get to know the colours that you are using; get to know whether they are opaque or translucent; get to know each colour's bias – whether a blue, for example, has a red or green tinge to it; get to know the colour wheel; then practise and practise again!

The list below explains the basic colours and mixes that I use, but finding the amounts of each colour and the pigment-to-water ratio is a matter of trial and error – and then practice. Learn the colour wheel and the bias, translucency and opaqueness of each pigment you are using.

For example, ultramarine has a red bias; cobalt blue is a flat blue; cerulean blue has a green bias; alizarin crimson has a blue bias; light red has an orange bias; cadmium red has a yellow bias; yellow ochre has an orange bias; raw sienna has a brown bias; burnt sienna has a red bias.

The colours listed below left that are followed by an asterisk (ie ultramarine for the blues, alizarin crimson for the reds and raw sienna for the yellows) are the most prominent pigments, and the colour mixes described here are other colours added to this colour. Different amounts of these additional colours will give the actual final colours that you require.

Basic palette

*= translucent pigments; using these when mixing will avoid flat, muddy paintings

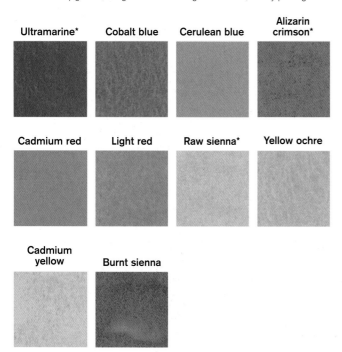

Ultramarine* Cobalt blue Cerulean blue Alizarin crimson*

Cadmium red Light red Raw sienna* Yellow ochre

Cadmium yellow Burnt sienna

Additional colours:

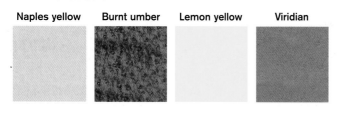

Naples yellow Burnt umber Lemon yellow Viridian

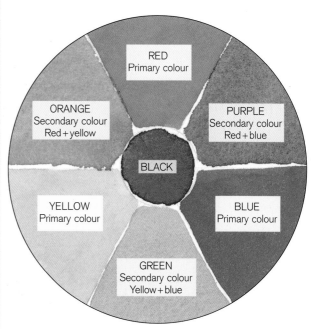

THE COLOUR WHEEL

RED Primary colour
ORANGE Secondary colour Red+yellow
PURPLE Secondary colour Red+blue
BLACK
YELLOW Primary colour
BLUE Primary colour
GREEN Secondary colour Yellow+blue

Using opposite (complementary) colours together will make black; adding the opposite colour on the colour wheel will give a shadow colour of the base colour you are using.

Try to avoid mixing more than three colours together or applying more than three overlays of colour.

EASY GUIDE TO COLOUR MIXING

The two end colours of the palette mixed together will give you the darkest colour that can be achieved with that palette. Except for really bright sunny days, the palette for landscape relies on subtle, tonal shades, and this palette should give you all you need, with the added bonus of knowing you have all the colours required to achieve bold statements when they arise.

• By mixing the first red (alizarin crimson) with the first blue (ultramarine) you will not just get a purple but a translucent purple – ideal for shadows.

• Now mix the first blue (ultramarine) with the first yellow (raw sienna) to give a translucent green, and just add the last yellow (cadmium yellow) to brighten this green.

• The first red (alizarin crimson) mixed with the first yellow (raw sienna) will give you an orange, and just add the last yellow (cadmium yellow) to brighten it.

If you use this method of mixing colours, not only will you achieve a more translucent effect but also you don't have to remember or think of what colours to mix together – and you will be on your way to avoiding mud. See below for easy reference.

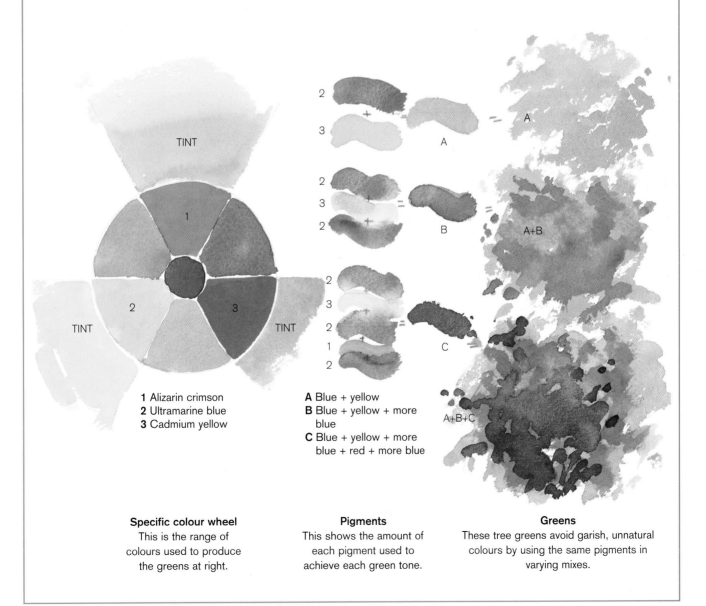

1 Alizarin crimson
2 Ultramarine blue
3 Cadmium yellow

A Blue + yellow
B Blue + yellow + more blue
C Blue + yellow + more blue + red + more blue

Specific colour wheel
This is the range of colours used to produce the greens at right.

Pigments
This shows the amount of each pigment used to achieve each green tone.

Greens
These tree greens avoid garish, unnatural colours by using the same pigments in varying mixes.

LANDSCAPE PALETTES

The examples here show various colours that I use to achieve the effects I want for landscape painting. All the examples are taken from my basic palette of colours (see page 36).

Sky

Ultramarine, cobalt blue and cerulean blue. For clouds use raw sienna, and use ultramarine and alizarin crimson down to the horizon. (See opposite for achieving perspective in skies.)

Clouds

Raw sienna, but also try light red and/or yellow ochre but keep it light to ensure translucency. For flat, grey skies use ultramarine and burnt sienna. Here I added cadmium yellow for a sunset.

Water

Use the reflection of the sky but lighter; darken with ultramarine in the front. The use of ultramarine as the predominant colour will give a translucent water feel to your work. Use lots of water!

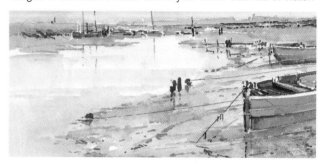

Trees

Use cadmium yellow and ultramarine. Add raw sienna to dull off the green, and either burnt sienna or alizarin crimson to darken. Use burnt sienna and yellow ochre for autumn trees.

Try changing the blue to cobalt blue for different effects; do not use cerulean blue. For silver effects use the additional colour of Naples yellow with cobalt blue. Don't use viridian on its own (although good greens can be obtained by mixing it with other colours). Some nice greens can be achieved by mixing the standard tree colours described.

Roofs

For red pantiles, use a light red base with cadmium yellow. While drying, add ultramarine and a green mix for texture and a lichen feel on foreground and/or details. Slate roofs vary, but cobalt blue and burnt sienna are normally effective. Try a blue/purple mix as a variation, or a brown one for shingle or old roofs.

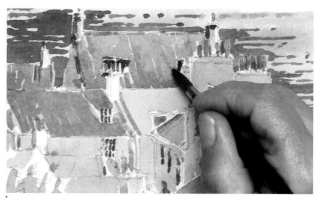

Brickwork

For red, use a burnt sienna base and add light red to make it more orange. For yellow, use raw sienna and/or yellow ochre.

Beach

For dry sand, use raw sienna and/or Naples yellow. For wet sand, use raw sienna plus burnt sienna and cobalt blue.

Windows

Do not paint these all one colour; use ultramarine and burnt sienna to make a dark, keeping it on the blue side. Wash off some colour, then add small amounts of blue or small areas of local colour for interest. For flat grey, use cobalt blue and burnt sienna or ultramarine and burnt sienna.

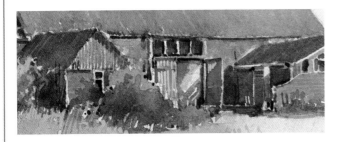

Shadows

Use ultramarine and some alizarin crimson (keep this on the blue side, as ultramarine already has a red bias), then add some of the colour you are painting the shadow over.

PAINTING SKIES

Most people really enjoy painting skies in their landscape work, and there are a number of ways to achieve the results you are seeking. I am very single-minded about how skies should be represented in landscapes, and feel that it is a lack of confidence that leads people to try gimmicks.

There are many techniques, but let's look at the sky colour and creating aerial perspective first.

A sequence for painting a plain blue sky from the top, above your head, to the bottom, the horizon, is as follows:

Ultramarine — red bias
Cobalt blue — flat blue with no real bias towards another colour
Cerulean blue — green bias
Raw sienna — orange bias
Alizarin crimson mixed with ultramarine — purple bias

If you were to paint these colours in bands in this order, by overlapping the edges and therefore creating mixed colours on the paper, a rainbow would appear as if by magic and would tell you that the refraction of light breaking up this sky, making the rainbow, indicates that the order and sky colours used are correct.

Try to stick to this sequence and, unless you are painting a sunset, go easy on the red by keeping the colours at the horizon a blue/purple tone. Make sure you lighten your colours as you work down the paper. You do not need to use all three of the blues, but do use two of them.

First wet the sky area with clean water. If you leave some parts dry, which you could do if you are intending to get hard edges, the pigmented wash will run around this area of your work, so be careful. Now wait.

As soon as the gloss goes from the paper and an eggshell finish is spotted, drop in your colours by floating the pigment across the paper — don't push, let the paper mix the colours together for you, and don't touch it while drying, or even when completely dry.

This is all a case of timing, as is watercolour in general: don't be impatient, mix the colours, wet the paper, wait, apply the colours, put the brush down and have a coffee.

Mixing Media

There are a number of other media that can be used successfully in the same way as, or mixed with, watercolour.

Pen and wash

If I were to use anything else in the watercolour line that was not pure watercolour, this would be it, and by far the majority of students love this style as well.

Pens used on smooth paper give a better line but do not take kindly to washes, whereas pens used on a rougher surface, such as NOT-surface watercolour paper, do not give such a nice line – but you can paint good washes. Normally

Venice Buildings and Canal. Pen and wash is a classic combination. Here, quick, sketch pen marks suggest a wealth of detail, while the free watercolour washes do not follow the areas of buildings, sky and water exactly, adding to the lively atmosphere.

I go for the latter, but sometimes when doing minimal pen sketches, I may choose a hot-pressed surface paper to emphasize the penwork.

The most successful pen and wash watercolours are those in which the balance between the line made and the wash painted is just right. I want the pen line to be the darkest mark I make, so I normally use black ink. Some people like to use sepia-coloured pens; this is fine, but you should lighten the washes to suit this colour, otherwise the balance will be wrong and the result will be nowhere near as good.

My normal penwork – no pencil first here – is sketchy, and although carefully planned, is carried out as swiftly as possible. Where one line would normally suffice I may draw two or three, because I am searching for the correct line, but I don't worry about the lines that may be wrong. This technique makes for a lively and fresh drawing, and the viewer's eye will pick out the right line.

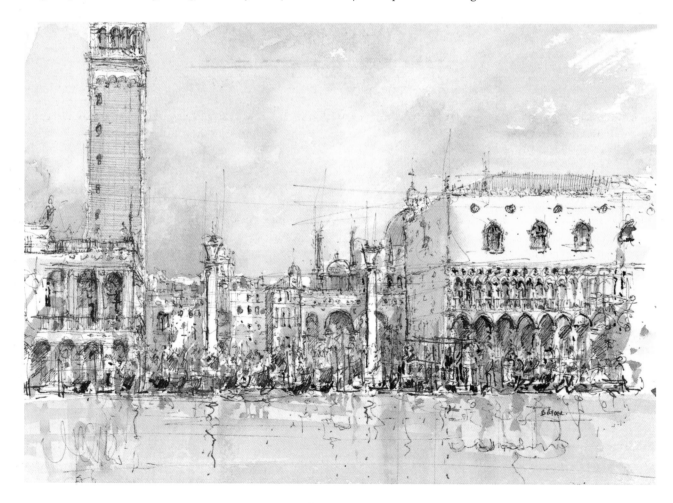

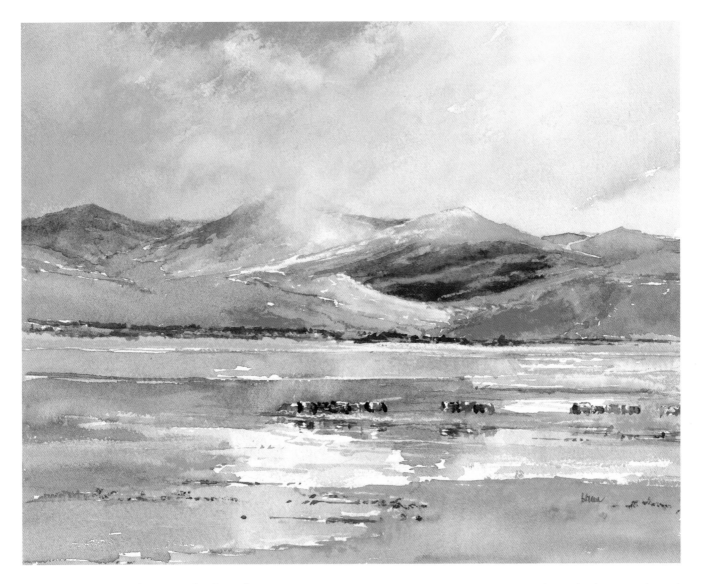

Mountain scene. Here, a delicate and restrained amount of pastel drawing over washes creates a soft, muted effect.

I always keep washes quite haphazard in appearance – they never stick exactly to the pen line but flow across the line to keep the lively feel going right to the end.

The best advice for doing pen and wash work is to be confident with your attack with the pen. Don't draw in unbroken hard lines; search for the right one with tentative marks, and if these are drawn in the wrong place, redraw them – you can't rub them out, so forget the problem.

Have a go – pen and wash could change your whole feeling about watercolour painting, and will definitely help your pencil work and your pure watercolours.

Watercolour and pastel

One very successful combination is applying soft pastel over watercolour. There are one or two rules I would apply here to avoid getting carried away and ruining your work.

First, do not take the approach that if your watercolour fails you can cover it with pastel! This will lead to a haphazard watercolour approach, where anything goes.

Pastel applied delicately over watercolours, allowing the watercolour to show through and be left untouched in places, can give some really good results; and like pen and wash, it is the correct balance that is the making of this form of painting.

Unlike pen and wash, however, refrain from using this technique too much, because although it does have its place in watercolour painting, it can become gimmicky.

So use pastels for creating a special effect or perhaps adding impact, and start your watercolour on the premise that this is going to be a watercolour that has a pastel overlay. Second, don't overdo the effect. Use the pastel in the same way and with the same approach as watercolour paint; use the side of the pastel to float over the watercolour wash. I lightly push and blend this in with my fingers so the edges of the pastel are not apparent where you want to expose the adjacent watercolour.

Marks made with pure pastel should go on last of all, as pure colour that can obscure the base watercolour.

Use a similar pastel colour to the watercolour underneath. Using a complementary pastel colour will separate the two mediums you are using, unlike using complementary colours of the same medium laid over each other.

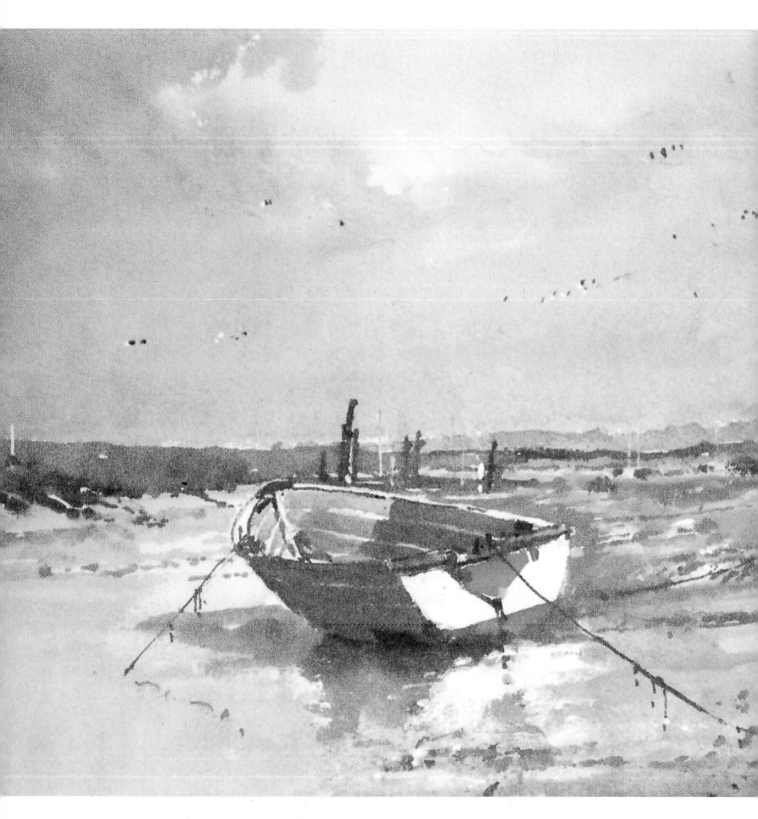

White Boat at Morston. This acrylic painting was done on 410gsm (200lb) Waterford NOT paper. I applied washes and overlays as for a standard watercolour; although acrylics don't quite work in the same way, practise will make perfect.

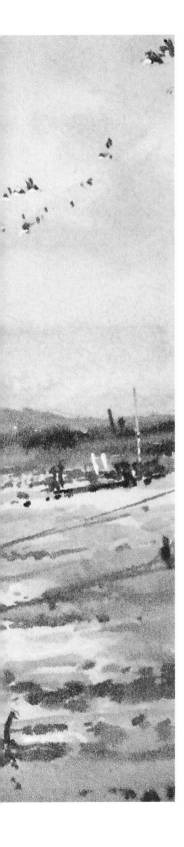

Acrylic

Used as a watercolour, acrylic paint can be watered right down and painted on watercolour paper, but at the end of the day, it doesn't have the lovely translucent nature of pure watercolour. However, you could use acrylic with soft pastel, which is quite a logical means of using both media.

Practising acrylics, even when watercolour has been mastered to some degree, is essential, as this is a different medium to watercolour and will act differently.

Autumn Trees. A lot of different mediums were used in this study: watercolour paint (some spattered), pastels and coloured inks.

OTHER MEDIA

I have included in this section very few different mixed mediums that can be used, but you can experiment further with:

- Bottled watercolours that are very intense and are available for airbrush techniques.
- Bottled acrylics.
- Coloured inks and dyes – used with watercolours and a combination of gold inks and perhaps soft pastels, these can give very interesting results, but they are more for use in abstract or contemporary paintings than traditional landscapes.

Whatever you use, do not gloss over pure watercolours in an effort to disguise what could be the poor quality of watercolour work by applying other mediums – you cannot get away with it forever.

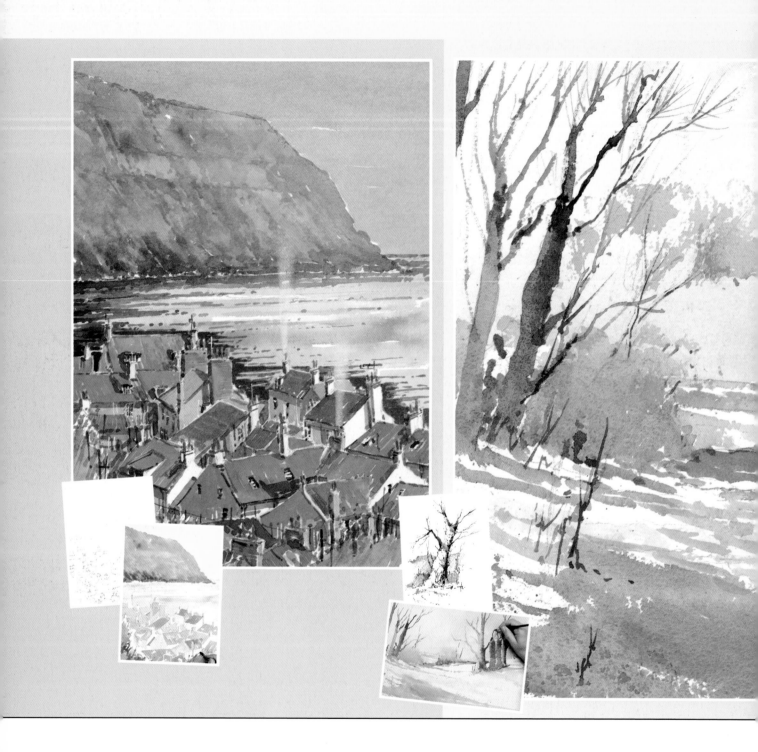

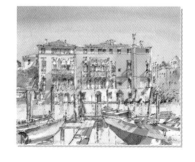
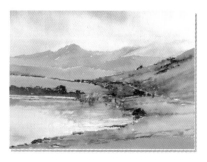
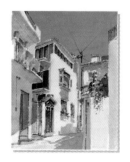

Projects

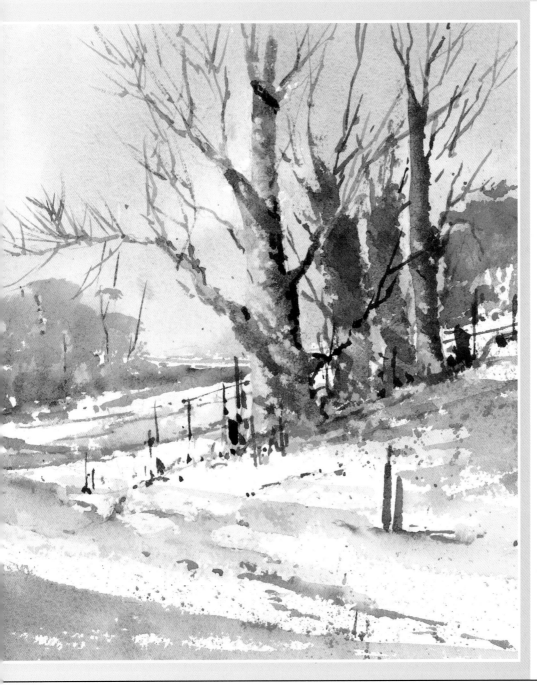

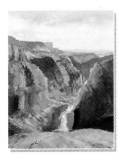
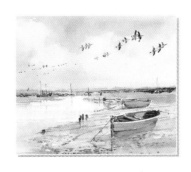
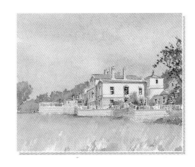
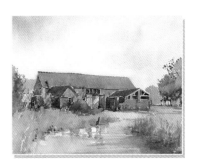

Beach huts

For this first project, I have chosen to paint some of the beach huts in Wells-next-the-Sea where I live in north Norfolk. As reference I took some photographs of the huts – none of them are what I would call good photographs, but they depict the type of arrangement of the huts that occurs along this stretch of the beach. They always hold interest for the painter, and I chose my subject from one of

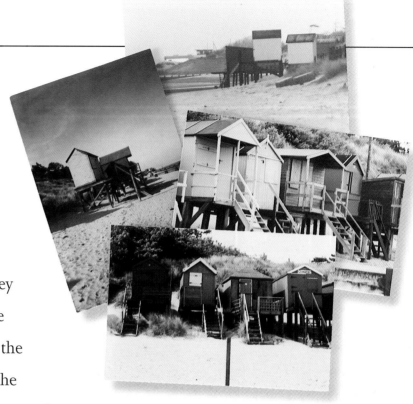

the photographs, leaving myself the option of adding or subtracting features for interest. My aim for this painting was to capture the huts in sunlight with sun and shade, and to capture a desolate beach that, by the inclusion of the windbreak, not only gives a better composition but hints at the beach being full of people later.

MATERIALS

BRUSHES
No. 14 round
No. 8 round
No. 3 rigger

PAPER
Saunders Waterford
NOT 410gsm
(200lb)

FINAL PAINTING
355 x 280mm
(14 x 11in)

PALETTE

Raw sienna	Ultramarine	Cobalt blue	Cerulean blue	Alizarin crimson	Burnt sienna	Cadmium yellow	Light red	Cadmium red

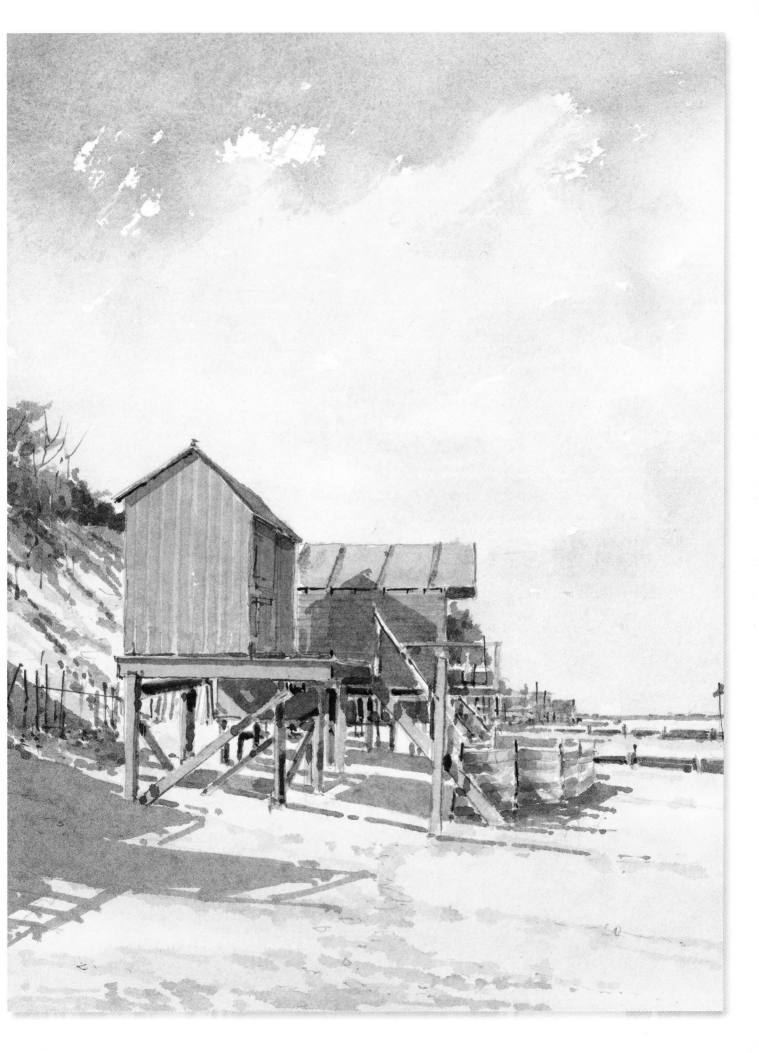

1 As I made the initial drawing I decided to help the composition by including a windbreak to stop the eye travelling off the right-hand side of the painting. I also made a mental note to change the dull brown colour of the second hut when I came to paint it. This is an example of how to use a photograph but not slavishly copy it.

2 I next put a light raw sienna wash over the whole of the painting, using a No. 14 round brush and working from top to bottom quite loosely and freely, until I had covered the whole sheet. After applying the wash I gently dabbed it with a piece of kitchen roll to take off some of it, and left it to dry completely.

3 For the dominant sky, working from top to bottom I started with ultramarine, painting down and then using the side of the brush to form the cloud edges. While this was wet I added cobalt blue and then painted in a raw sienna wash to form the clouds, leaving hard top edges where required. I painted cerulean blue in a horizontal direction, then changed to a mix of ultramarine blue and alizarin crimson to finish at the horizon, working very quickly and confidently. While the sky was drying I put another slightly stronger raw sienna wash over the bottom of the picture, wiping it off to soften it, and added a little burnt sienna into the raw sienna in the foreground to warm it.

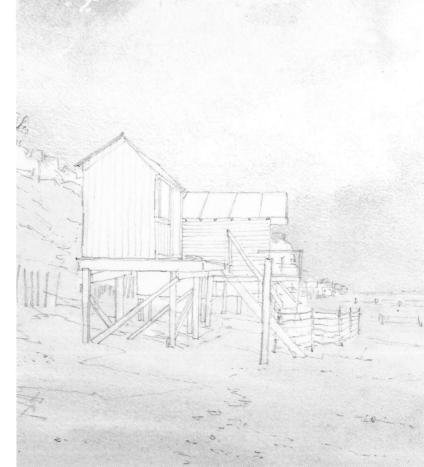

4 To add some colour to the hill I mixed cadmium yellow with ultramarine, keeping it on the blue side, then added small touches of raw sienna to stop it going too green and to tone it down. I used a No. 8 round brush to paint into the trees up to the structure of the beach huts, and added a little more cadmium yellow and dragged the colour down the hill. With the same brush I painted cerulean blue on the main beach hut and burnt sienna on the next hut, leaving negative spaces to create form.

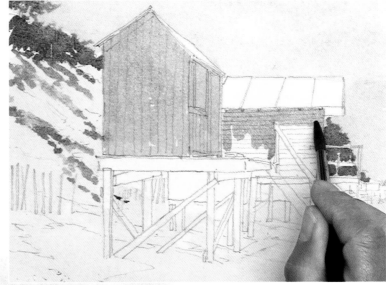

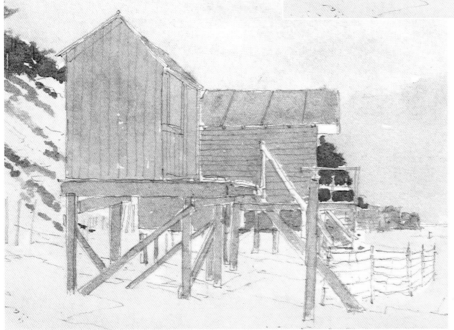

5 I painted the roofs using ultramarine and raw sienna to achieve a flat colour. For the beach hut behind the other two I changed the colour a bit and used a light red to add interest. I painted the distant beach huts a light purple and dropped in red and green to help the final effect. I next blocked in some of the struts with burnt sienna, leaving some of the original colour, and dropped in some purple to darken the shaded areas of the struts.

TIP

To test whether a wash is dry use the back of your hand, not the palm, which may be damp with moisture.

6 The next part was to block in all the white bits and paint the fences and windbreak posts, dabbing off the paint to avoid too dark a mark at this stage. I decided to put a bit of colour into the windbreak for impact, so I painted the stripes using cadmium red, cadmium yellow and cobalt blue, keeping them in line tonally with the other colours. I then left the whole painting to dry completely and stood back to look at the results before the next stages.

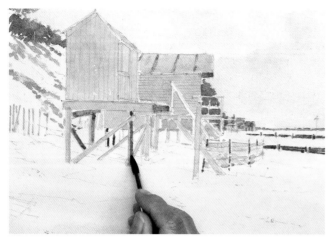

7 From here, the painting was all about making marks and suggesting things without too much definition. I put the horizon in with purple, adding a little green for the grass on the sand dunes. I mixed up a slightly darker burnt sienna and ultramarine and went over the breakwater, using the same colour on the overhang of the beach hut. I then painted the uprights of the windbreak. When defining the darker tones under the huts, I added more lines for supports. I darkened the right side of the hut with cerulean blue and strengthened the windbreak colours for translucency.

8 With the tip of a No. 14 brush I added more texture to the beach using raw sienna and burnt sienna. I then used a bit of ultramarine for the shadow sides of the footmarks (**see inset**). I used a No. 8 brush to put some colour, and to make marks, on the trees, darkening little bits so as to break up the flatness. Using light red I darkened under the hut before working more purple darks on to the shadow side of the blue beach hut to break it up a bit.

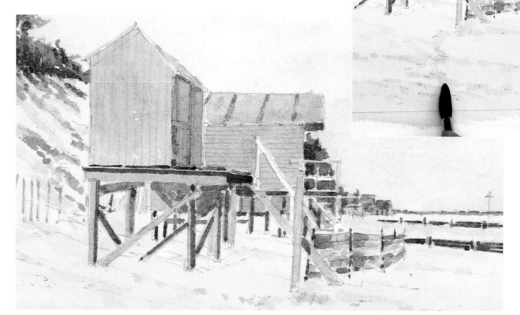

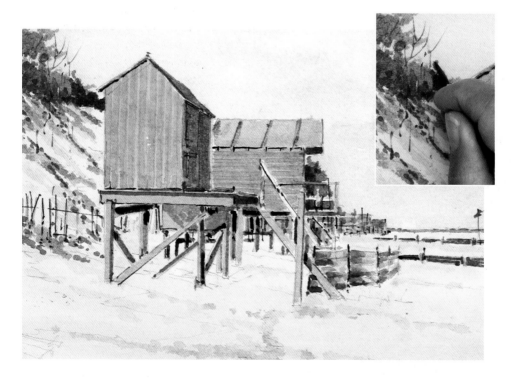

9 Using burnt sienna I added the boards on the brown beach hut, dabbing off to loosen it, and then moved on to the blue hut with cerulean blue. At the bottom of the hut I dropped burnt sienna into the blue to darken it off. I darkened the shaded side by making a few marks and then dabbing off, then darkened the roof of the brown beach hut and put in a line for the left-hand slope of the hut, just suggesting the eaves by using the side of the brush. I made quite dark marks for the posts to bring them forward, darkened the tone of the foreground tree, then loosened it a bit, and made a few more marks on the slope of the hillside (**see inset**).

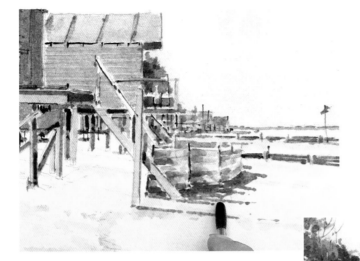

10 I put final touches on the windbreak, darkening some areas and adding shade by dabbing off. To draw in the fine lines of the posts I used a No. 3 rigger brush with a mix of blue and brown. This is the stage that can make or break a painting, so be careful and don't do too much or go over the top with these more detailed marks – stop, step back and look. I decided that the brown beach hut needed to be darkened on the shadow side to make the light work.

11 Putting on the shadows is the most important stage, as it brings everything to life. I always use purple for shadows in a ratio of 3:1 on the blue side, then use a touch of the base colour. I placed the shadow of the tree down the slope and the building, painting the shadows in the distance lighter, and then put in the shadows at the back of the beach huts and under the breakwater. I darkened the shadow of the windbreak with more pigment and a bit of raw sienna, and extended the shadow on to the beach.

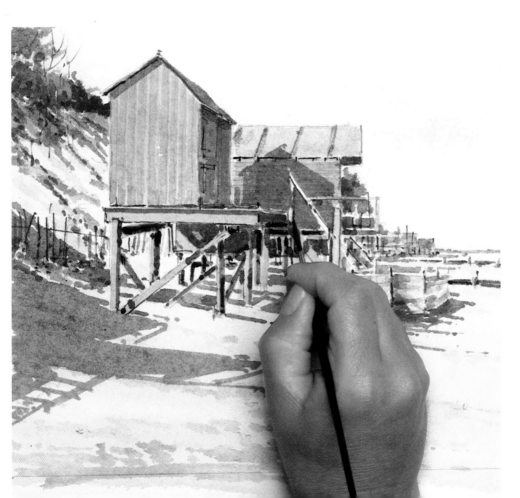

12 I painted under the huts using a dark mix of ultramarine and alizarin crimson with a touch of raw sienna, and then changed to a No. 14 brush to add shadows coming from outside the picture. I worked extremely quickly, making marks suggesting balconies and indicating the slope of the beach. I added a bit of burnt sienna to the mix and painted the shadow of the brown beach hut up against the blue beach hut. I finished by adding the touches that provided the last areas of emphasis.

Buildings and water

After the simple perspective of the beach huts, this project looks at a more complicated elevational treatment of buildings, where the only real perspective is in the foreground.

I am lucky to have been to Venice a few times, and never get tired of painting it. I may never do it justice, but I decided to do this pen and wash painting of the Palazzo Segredo opposite the *pescheria*, the fish market. Included here is a photograph of the building, and although I stuck more or less to the subject, I loosened up the pen drawing and watercolour wash to achieve the result I was looking for.

Here I have tried to capture a typical Venetian scene, with the Grand Canal, boats and characteristic architecture. There may be a lot going on, but if you are presented with such a scene, break it down into its individual elements, starting with the main subject, the buildings, then add the other bits to this structure to complete the scene.

MATERIALS

BRUSHES
No. 12 round
No. 8 round
PENS
0.1 waterproof
0.7 waterproof

PAPER
Saunders
Waterford NOT
410gsm (200lb)

FINAL PAINTING
240 x 292mm
(9½ x 11½in)

PALETTE

Cobalt blue	Raw sienna	Light red	Ultramarine	Cadmium yellow	Burnt sienna	Alizarin crimson	Cerulean blue

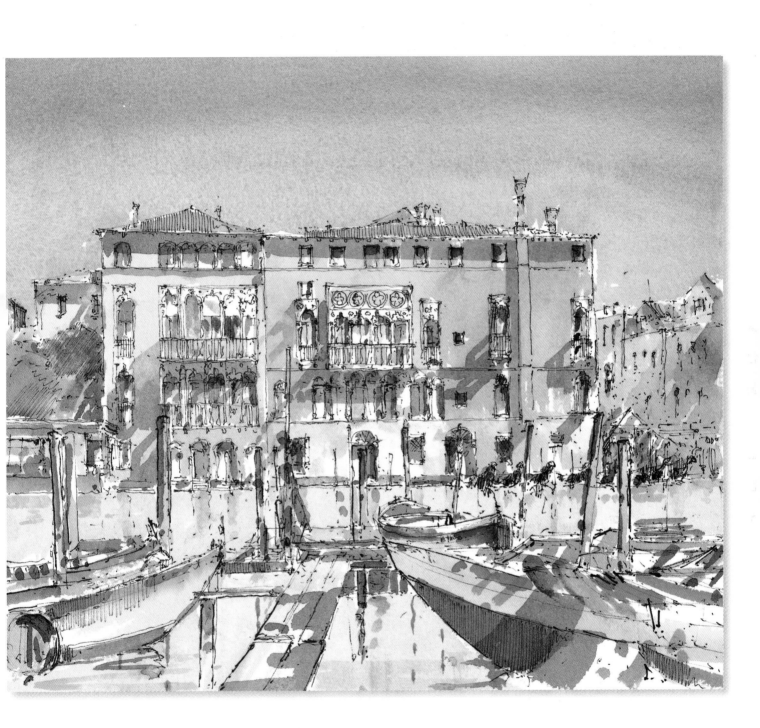

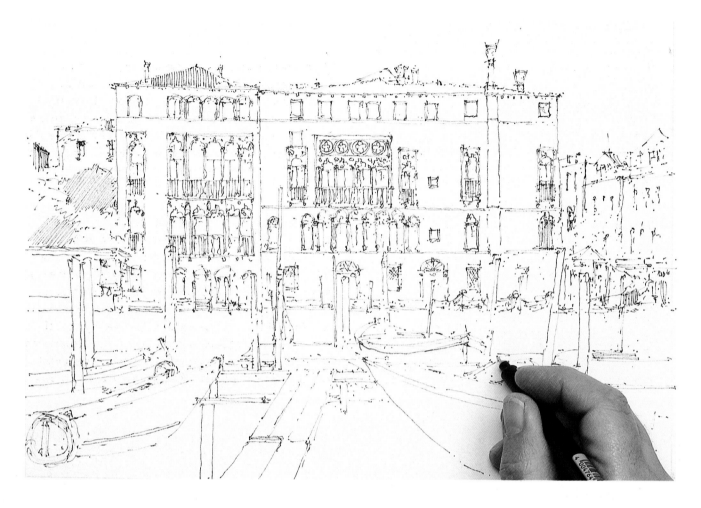

1 When drawing straight on to the page with pen, ignore any 'wrong lines'. Don't just do hard edges, but feel for the shapes, contours and patterns, using a combination of long strokes and small marks. Starting with a thin pen (0.1), I worked from the highest part of the focal point, here the central building, and used it to find the rest of the view. I worked from outlines first, and then added the architectural details, doors and windows after. Note the contrast between the quite detailed building and the larger foreground shapes of the gondolas and jetties. At the edges I went 'sketchy' and added a small amount of pen hatching.

TIP
You can always go back in with the pen in later stages, so don't overdo it early on.

2 I switched to a 0.7 pen to reinforce some of the lines with thicker, darker lines, looking for the balance in the drawing by trial and error; there are no hard and fast rules for this – experience and practice will guide you – but the drawing should work on its own merits. Using this thicker pen, I loosened up the drawing, pressing hard in some places and not in others.

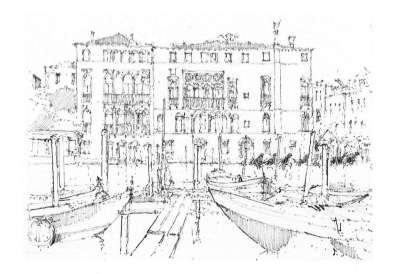

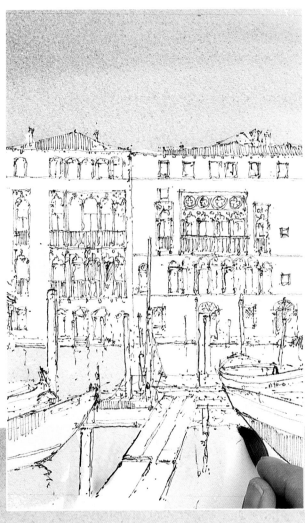

3 When the penwork was completely dry, I began the washes by applying a flat sky, using cobalt blue and a No. 12 round brush, and lightened up the colour by diluting it with more water as I came down to the roof line. Using an even lighter version of the same colour, I then put in the water at the bottom; because it's over a pen drawing, I was not filling in the drawing but floating across it. I let all the washes dry.

4 For the buildings on the far right and left, I put some raw sienna and light red in the same mixing well, picked them up with the brush and blended them on the paper. I then used a mix of ultramarine and cadmium yellow for the green of the trees on the left, varying the colour for different shades. I returned to the raw sienna/light red technique for the central part of the building, this time slightly redder, leaving most of the windows as white paper. After adding more colour while the main wash was still wet, even a little ultramarine for texture, I used some kitchen roll to dab off the colour and knock it back.

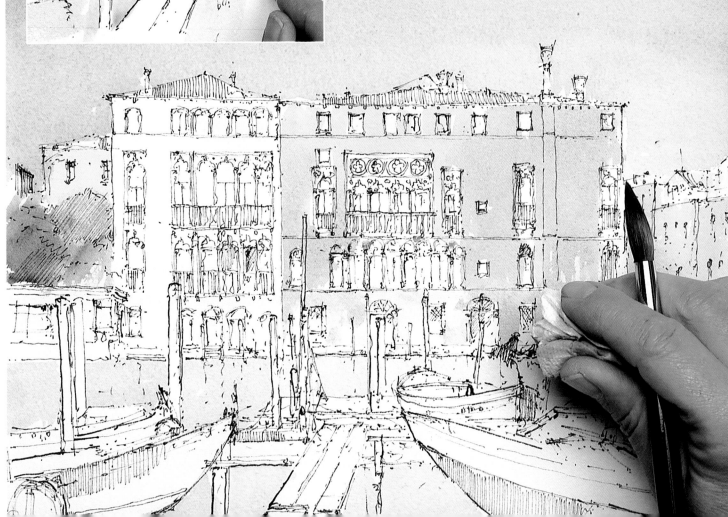

5 | For the creamy colour of the left-hand building I used a mix of raw sienna, light red and ultramarine, and then mixed a little cadmium yellow and light red for the right-hand boat. I next combined all the colours with freer strokes for the boats and jetty, varying red, yellow and brown as dominant shades, keeping the feel loose and washy around the focal point of the building and getting rid of most of the white. Using ultramarine and burnt sienna, I blocked in some of the windows.

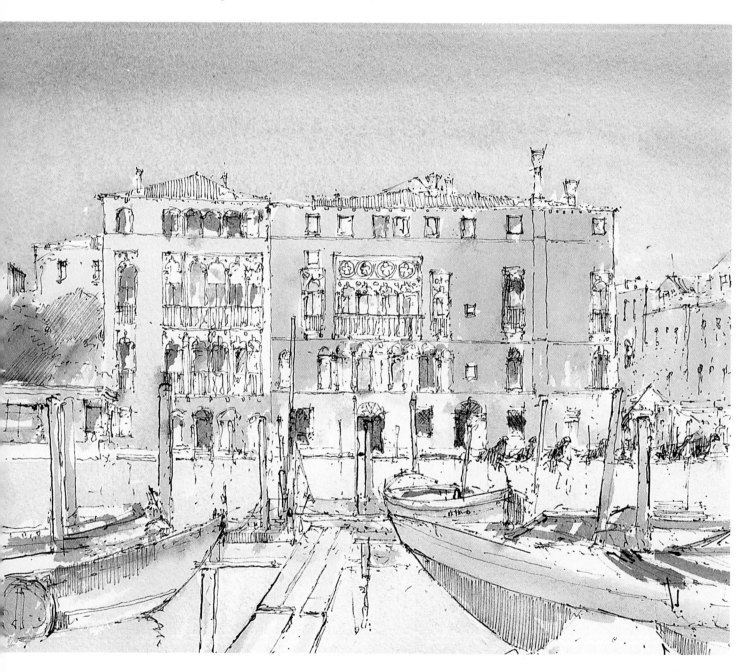

TIP
At the latter stages, be careful to stand back and look at the painting at regular intervals, and do not fill in every part just because you can — leave white areas without making them too obvious.

6 | Having changed my water, I used a No. 8 brush to mix cadmium yellow and light red for the orange of the roofs, and then applied small marks at the left to add some shadow on the trees, with a mix of ultramarine and burnt sienna. I mixed ultramarine and alizarin crimson for the purple shadows on the left-hand building, then used the same colours to add shadows and simplify the buildings on the right. To suggest a few reflections in the water I made a greyish mix of ultramarine and light red, and added raw sienna to this for some parts. I applied darker blue washes across the boats and jetty, then cerulean blue for the brighter foreground blues.

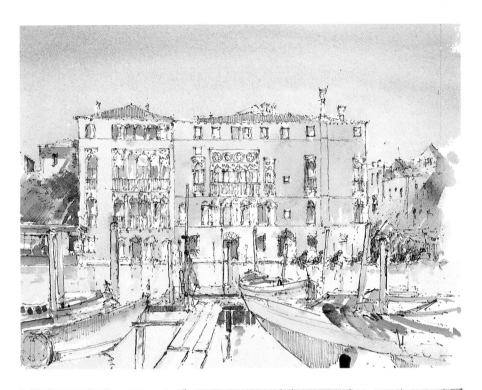

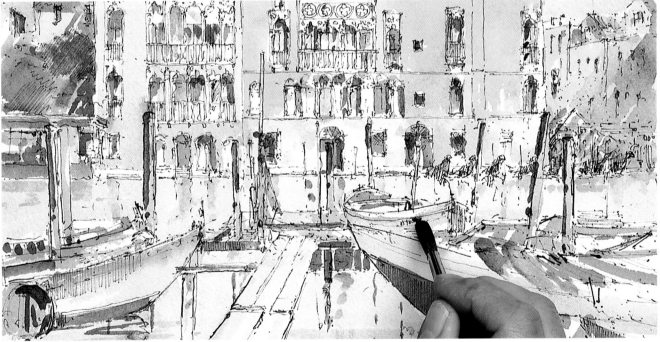

7 | For the darkest colours in the foreground, I applied stronger mixes of the colours already used. For the windows of the main building, I applied the mix of ultramarine and burnt sienna, again not filling them all in and dabbing off where required; I then applied cerulean blue for the lighter windows and shutters. To indicate reflections in the ripples in the foreground water, I used a diluted orange mix, dabbed it off immediately, and then applied a darkish brown on the shadow sides of the posts. At this last point I was making marks with colours, reflecting what I did with the pen at the beginning, and added bright red to warm up and finish the painting.

TIP

Don't try to paint every single window or door accurately; rather, look to get an overall feeling that is not too consistent.

Misty mountains

This project is completely different to the last one – there are no buildings – but the link is the depiction of water, which was relatively unimportant in the last project but is one of the main elements of this painting, of Capel Curig in north Wales. My main concern was painting the mist, as there are different ways to do this: painting wet-on-dry and taking out colour with a tissue; or wetting the sky down to the hard edge of the mountain and taking the water across the top of the mountain. I decided to wet the paper first and then see what happened – on location I'll take two or three goes at this subject, but I made a simple sketch here for clarity.

A light and translucent wash, applied in basically one layer, is what I was after to depict the soft feel of the scene and achieve the mist on the mountain and rolling green hillsides typical of an area that has abundant rainfall; I wanted to avoid the more layered approach that is evident in project 6 (see page 78). A wet-in-wet sky is a good way to achieve this overall effect in this instance, although I might well vary the approach in another painting.

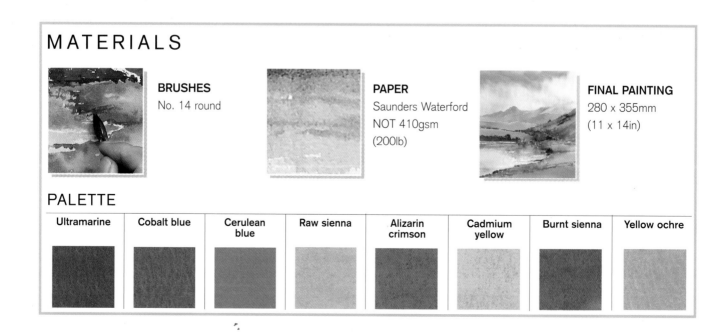

MATERIALS

BRUSHES
No. 14 round

PAPER
Saunders Waterford
NOT 410gsm
(200lb)

FINAL PAINTING
280 x 355mm
(11 x 14in)

PALETTE

Ultramarine	Cobalt blue	Cerulean blue	Raw sienna	Alizarin crimson	Cadmium yellow	Burnt sienna	Yellow ochre

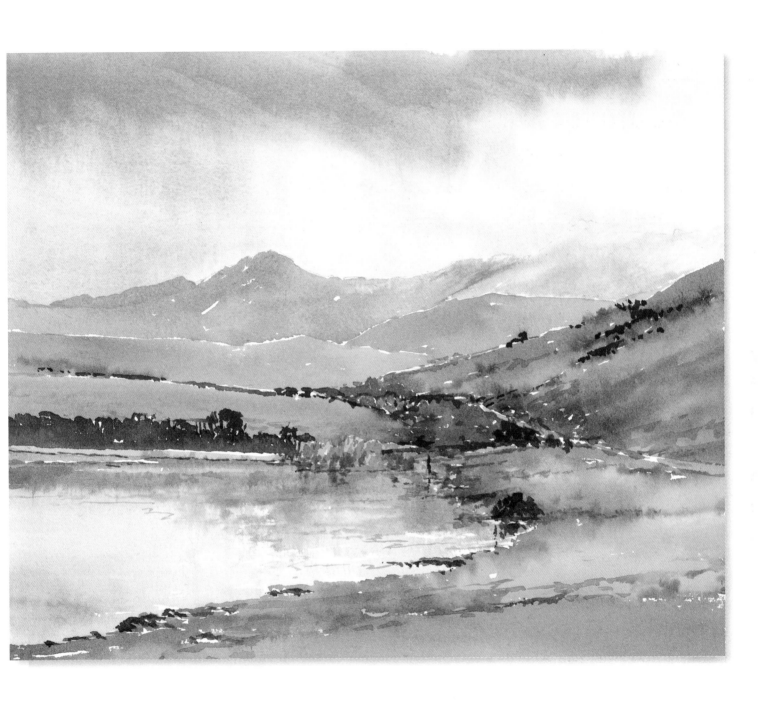

1 Wetting the sky area with clean water and a No. 14 brush, I took the water across the top of the right-hand mountain for the mist area, then let the water dry a little, waiting for the wet surface to lose its gloss and begin to turn matt – this is the scary bit! I then applied a wash of ultramarine into the top of the wet part, and added cobalt blue and very diluted raw sienna with the side of the brush, with cerulean blue nearer the mountains and a purple mix of ultramarine and alizarin crimson. I brushed all the colours back into each other, and picked up the bottom edge to create a soft feel, very lightly teasing the colour into the mountain at the right.

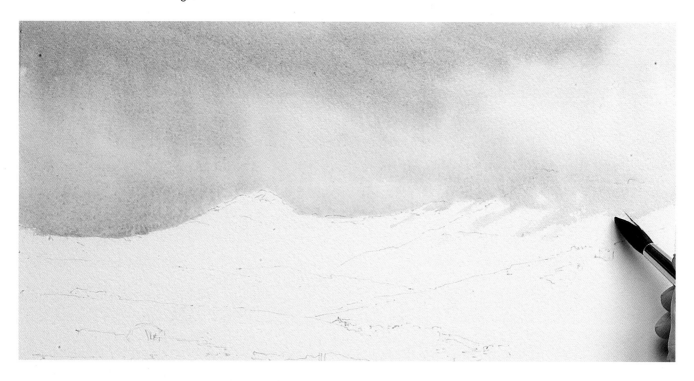

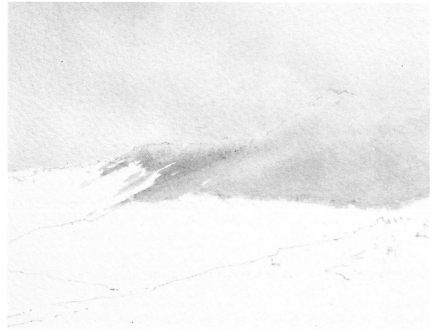

2 While the right-hand mountain was still a little damp, I painted into it with a mix of ultramarine and raw sienna, working delicately and keeping the colours light and translucent. I gently added some more purple mix with the very tip of the brush, again working it back and using a damp tissue to very lightly touch the pigment off in places. I then took a break and allowed the sky area to dry completely.

3 With the blue-purple mix and a green made from ultramarine, raw sienna and cadmium yellow, I started to paint in the line of the mountain at centre and left. Working from the top down, I applied the colours wet-in-wet, which created a certain amount of running together. I then added more blue to the misty areas of the right-hand mountain, dabbing to take off the hard edges and keep the misty effect.

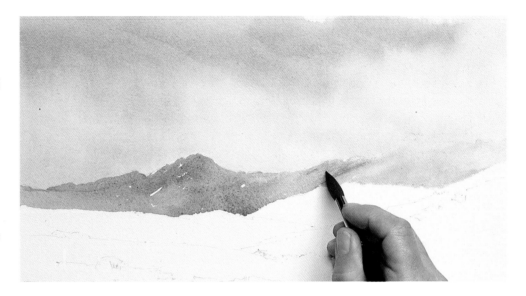

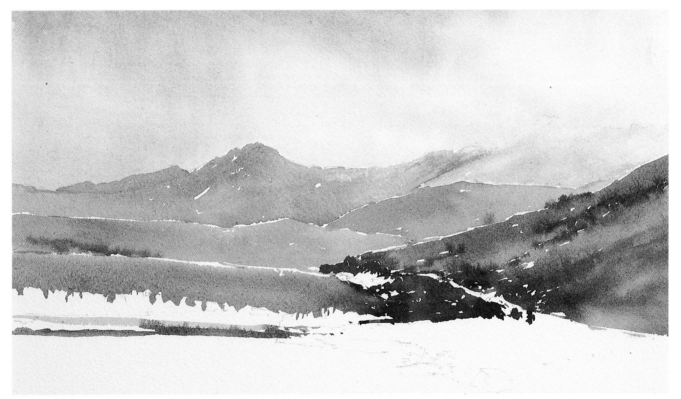

TIP

Use the very tip of the brush to work the 'meeting points' of the cloud and mountain.

4 To start the flat, subdued colours of the middle ground, I used the green mix with a bit of the purple mix, then added a small amount of cadmium yellow to the green for the green on the far left, bringing this through to the middle and below the first green wash. I left tiny white lines between the washes to keep the translucency and light feel. While these washes were still wet I added the darker green banks of trees – applying a bit of raw sienna with the green, not fully mixed in the palette, to give variety to the washes. I dropped in a darker green mix with alizarin crimson for the right-hand trees, keeping everything quite loose and spontaneous, and made the wash darker towards the lake on the right.

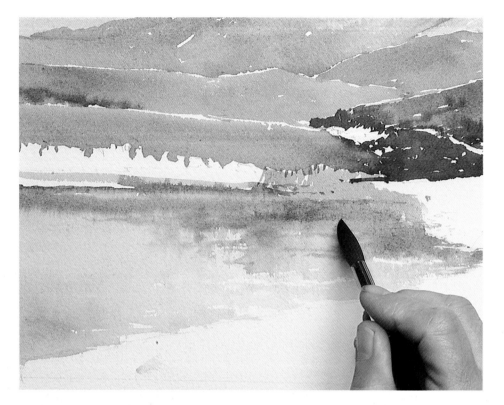

5 To paint the lake I used a flat wash of cobalt blue with a tiny bit of green in it. I touched this against the damp green of the shore, dabbing it off for the ripples and reflections, then deepened it with ultramarine. While this was still wet, I added green along the top of the lake and let it run, then touched in really delicate purple strokes and marks for the broken reflections of the tall left-hand mountain, pulling them in with a tissue to soften them. I next worked a greyer mix into the far right-hand of the lake, to create a hard edge, then applied a raw sienna/burnt sienna mix for the rocks above the lake and into the top of the lake for reflections.

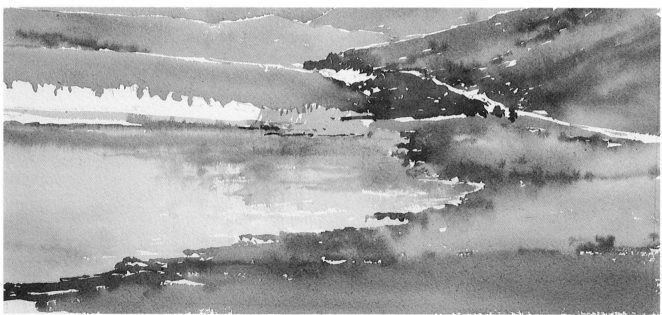

6 For the foreground land on the right I worked in the brighter green mixes (note the plural) very wet and translucent, adding yellow ochre to some areas – the colours had to create the visual interest, as there weren't many other features in this area. I painted into the lake bottom, making some harder edges to delineate the land edge. I applied darker greens wet-in-wet for the trees, bushes and hedges, dabbing them to keep them soft. I then allowed everything to dry.

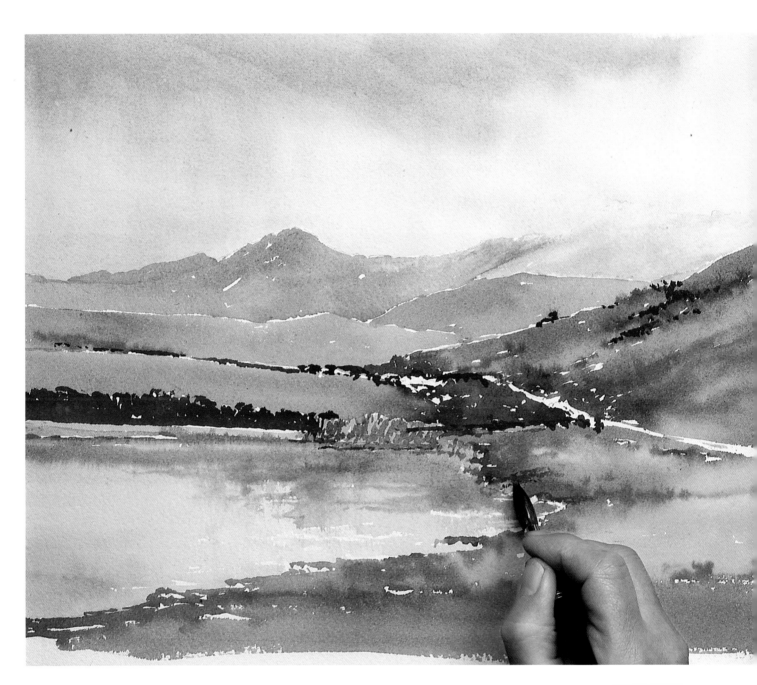

7 I mixed a vivid dark green – more blue than yellow, with a touch of crimson – for the main line of trees above the lake; then a little cobalt blue below. For the contours on the rocks I used small marks of burnt sienna/ultramarine, and then applied the dark green to reinforce some of the further trees and clumps. I took out some of the remaining white paper, using ultramarine and the green and brown mixes, but made sure to stop before I lost the freshness and translucency. To finish, I added and dabbed back a few semi-hard lines to show movement in the water.

TIP

To paint water use a very wet wash of your chosen pigment

Backstreet shadows

From soft, misty Welsh mountains we now look at the hard edges and bright colours of a village in Skiathos. This view could be anywhere on the Greek islands, and shows the harsh sunlight and purple shadows that are characteristic of this area.

Although I invented some shadows to relieve the expanse of wash on the street, don't go mad by adding inappropriate areas of shadow in your painting; give some thought to the direction of light, particularly in a painting of bright sunlight such as this, with its flat blue sky between the buildings.

MATERIALS

BRUSHES
No. 12 round
No. 10 round
No. 4 round
No. 3 rigger

PAPER
Saunders Waterford
NOT 410gsm
(200lb)

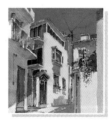

FINAL PAINTING
345 x 240mm
(13½ x 9½in)

PALETTE

Ultramarine	Cerulean blue	Raw sienna	Cadmium yellow	Naples yellow	Light red	Cadmium red	Burnt sienna	Cobalt blue	Alizarin crimson

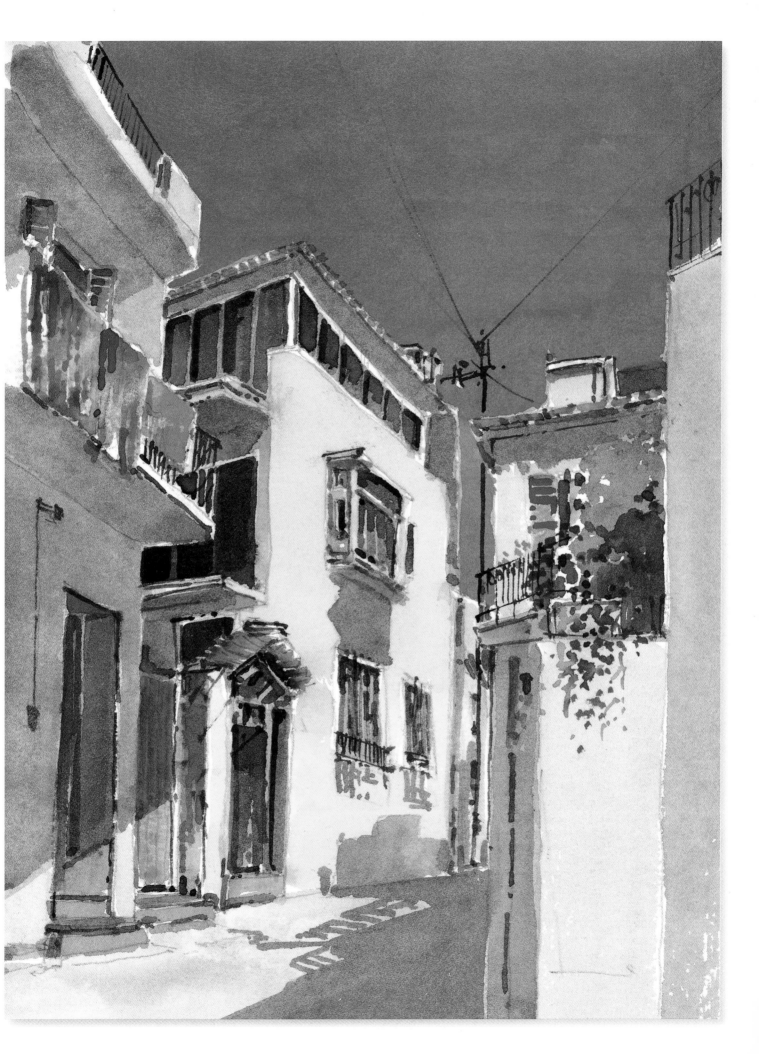

1 │ The view looking up the narrow street provided an exercise in perspective. Without careful attention at this stage, it would have been easy to draw the perspective wrong without realizing it (see page 23 for basic perspective). Here, the perspective was more important than the accuracy of the individual elements of the drawing.

2 │ With a No. 12 round brush and a mix of ultramarine and cerulean blue, I applied a wash to depict the sky. Working quickly from the top, I added more water to the mix to make the wash lighter as I reached the area around the edge of the buildings, working carefully as I painted the little area between the two main buildings.

3 | Using the same brush and a raw sienna wash, I loosely painted in the surface of the street, adding a touch of cerulean blue to show the areas that reflected the colour of the sky.

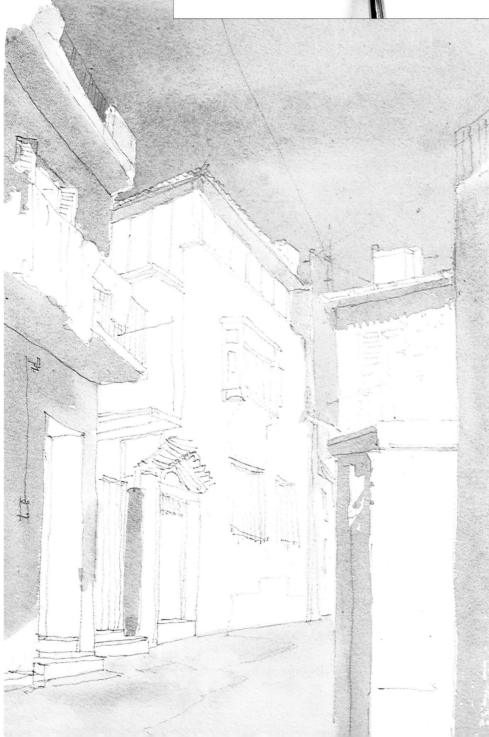

4 | I painted in the shadows on the buildings – a different method than usual, due to the subject matter – using the same mix of raw sienna and cerulean blue. By changing the proportions of the mix, I was able to show some variation in the strength of the shadows. I allowed small areas of the paper to show through for highlights.

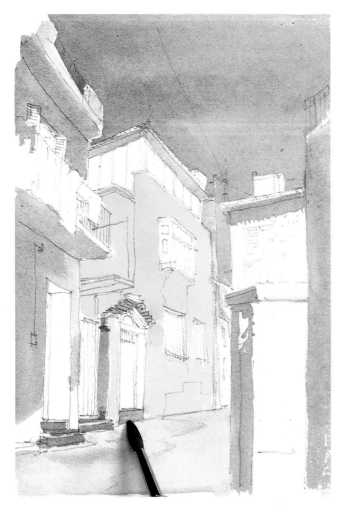

5 Again using the No. 12 brush, I used a mix of cadmium yellow and Naples yellow to block in the walls of the main building. Then, adding a little light red and a touch of ultramarine to the mix, I painted in the doorsteps and the little porch over the entrance of the main building.

6 I made up a green mix using cadmium yellow and ultramarine, and painted in the foliage on the balcony, allowing areas of paper to show through as highlights. For the colourful washing on the left I used cadmium red, cerulean blue and a mix of cadmium red and cadmium yellow. I applied a light mix of burnt sienna and ultramarine to paint the windows on the covered balcony, the door openings and the windows, and then applied cerulean blue to the door on the left and on the shutters. I then allowed the painting to dry completely.

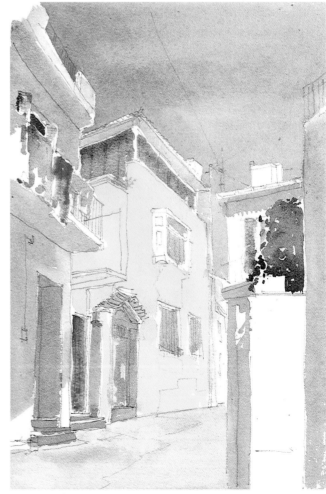

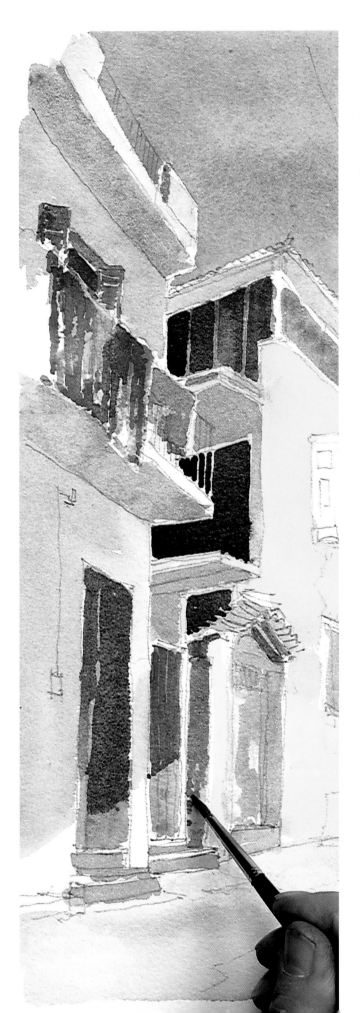

7 With a No. 4 round brush and using a mix of cobalt blue and burnt sienna, I painted in the shadow on the side of the main building, and then used cadmium red to paint into the first wash on the red cloth, blotting out to suggest texture in the material. I repeated this on the blue washing using a darker cerulean blue, and worked on the orange cloth in a similar way. Next, I strengthened the darks in the balcony windows and added the window on the side of the main building. For the shadow side of the main building I used the original yellow mix with a touch of ultramarine to cool it off, and I strengthened the shadows across the doorways on the left.

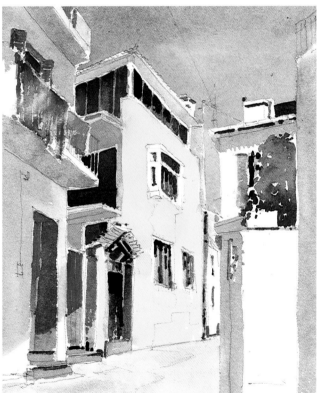

TIP

When using a photograph as reference, be careful not to make a direct copy, as this can look misleading in a finished painting and create a mechanical finish. Always step back at each stage and review what you've done.

8 I used a mix of ultramarine and burnt sienna to add darks to vary the shadow in the window areas, doorways, on the chimney and in the balcony area. I took care not to paint out all the base colours, which would have resulted in flat, heavy areas of colour.

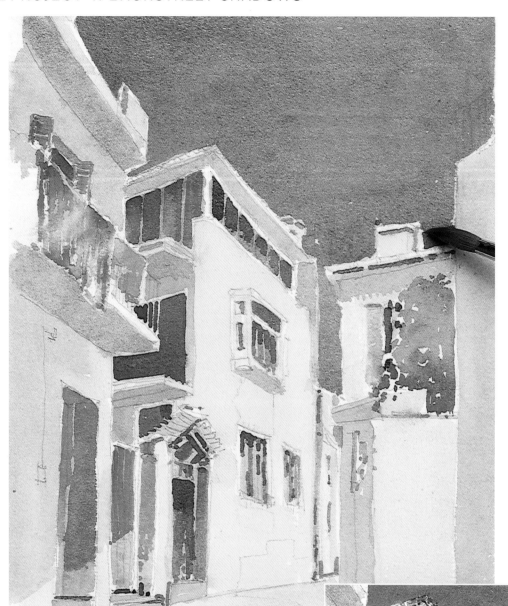

9 Changing back to the No. 12 brush, I used a mix of cobalt and alizarin crimson to tone down the white areas on the building on the right. To suggest form, I washed a weak mix of raw sienna with a small touch of ultramarine across the underside of the balcony. Switching my attention back to the sky, I intensified the blue by adding a second wash of cerulean blue and ultramarine, adding more water to dilute the mix as I worked nearer to the edge of the buildings. I allowed everything to dry again.

10 It was now time to start pulling together the painting by defining form and adding detail. With the No. 4 brush I went over the painting with the original mixes, strengthened for the purpose. I then used light red and cadmium yellow to show the tiled roof edges, which helped to shape the building, pulling the corners towards the eye, and I added the roof on the porch of the main building.

11 I switched to a No. 3 rigger brush and used a mix of ultramarine and burnt sienna to draw in the wrought-iron balconies and wiring on the wall. At this stage I was really 'drawing' with the brush to make the last defining marks around the doorways, windows, balconies and undersides of the roofs. I included the telegraph pole and a few wires – the telegraph pole helped to unite the buildings on the two sides of the street, and the wires added a touch of interest in an otherwise flat sky. I also introduced some splashes of colour on the right in a cascade of bougainvillea flowers, using alizarin crimson and ultramarine.

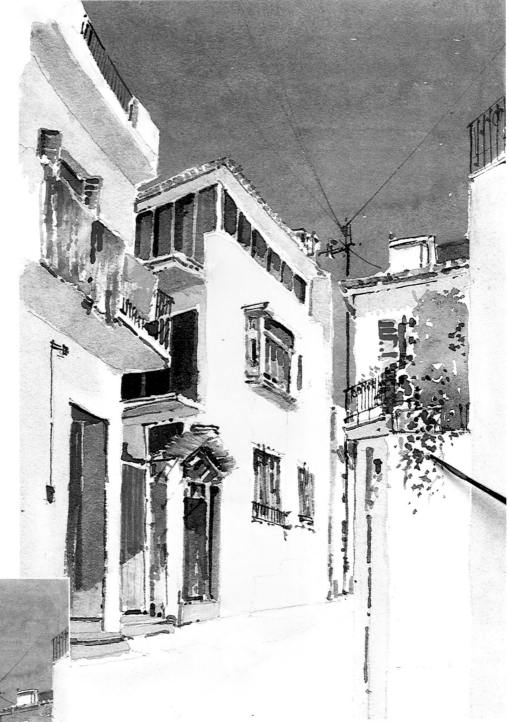

12 Finally, with the No. 14 brush I strengthened the all-important shadows and added an area of shadow in the lower right. I used a mix of ultramarine and alizarin crimson and swept a wash across the area in shade, working boldly as the heavy shadows added impact. Occasionally I switched to the No. 4 brush to define fine areas of shadow, such as those thrown by the railings at the windows.

TIP

Try shadow colours first and make one sweep of the brush. You do not want to overpaint these, as there is a danger that you will lose translucency and achieve an opaque effect.

Snow scene

In the last project I used quite bright blue/ purple shadows to depict bright sunlight shining on whitewashed or coloured walls in hot temperatures and sunny skies. In this painting, the same shadows can be used again, this time to depict a bright, cold day in the country, with shadows cast across snow and no real focal point. I opted for a fairly quick approach with minimal overlay, and finished the whole scene off with some soft pastel highlights. The idea was to create the feeling of snow – the tree shapes are not too detailed, because the Rough paper does a lot of the work; it provides the sparkle in this snow scene, and the limpid sky and softer blue/purple shadows make a contrast with the hard-edged trees and posts. I have given this scene plenty of colour, to suggest a bright and crisp sunny day, so if you were after a more subdued effect you might want to tone the colours down a little.

MATERIALS

BRUSHES
No. 14 round
No. 6 round
Stiff flat
No. 4 round
No. 4 rigger

PAPER
Arches Rough
600gsm (300lb)

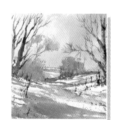

FINAL PAINTING
280 x 405mm
(11 x 16in)

PALETTE – WATERCOLOURS

Ultramarine	Alizarin crimson	Raw sienna	Cerulean blue	Burnt sienna	Cadmium yellow

SOFT PASTELS

Naples yellow	Raw umber	Orange	Olive green	Grey	Green earth	Light orange	Bright purple

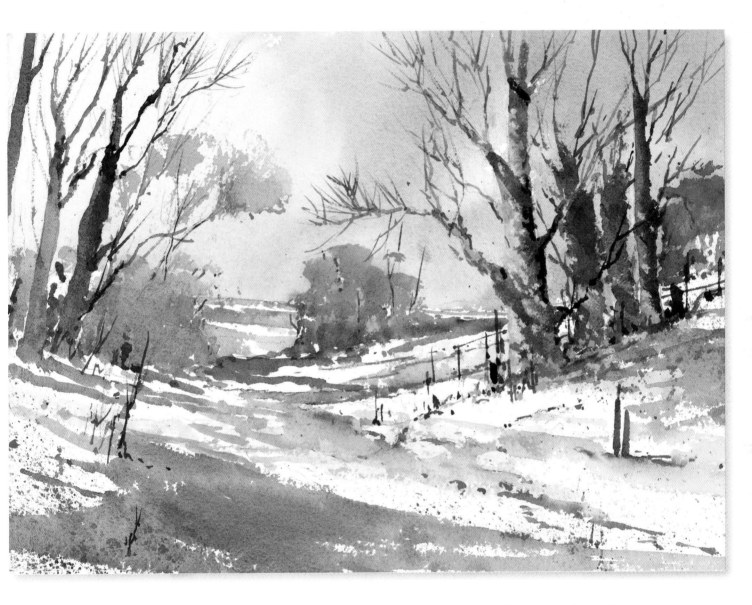

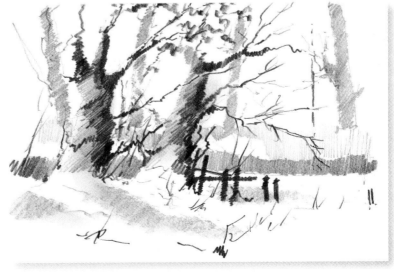

1 | In contrast to the previous project, the initial drawing here was not concerned overmuch with perspective – the aim was to loosely indicate the composition and framework of the scene. I worked quite lightly to draw this. Studying tree shapes will help you understand which details need to be included and which can be edited out.

2 | Loading a No. 14 round brush with clean water, I loosely worked the sky area into the trees, let this dry a bit, then added an ultramarine and alizarin crimson wash into the wet areas, dropping in some raw sienna below and cerulean blue lower, straight across the trees. While this was still wet, I darkened the purple at the top and dabbed out the tree shapes with some kitchen roll. Because the light was coming from the top left, I darkened the areas to the right – wet-in-wet creates its own form, so I worked with this to make lighter and darker areas, creating a soft, limpid winter effect in the sky. I then let all the washes dry.

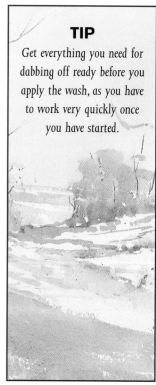

TIP

Get everything you need for dabbing off ready before you apply the wash, as you have to work very quickly once you have started.

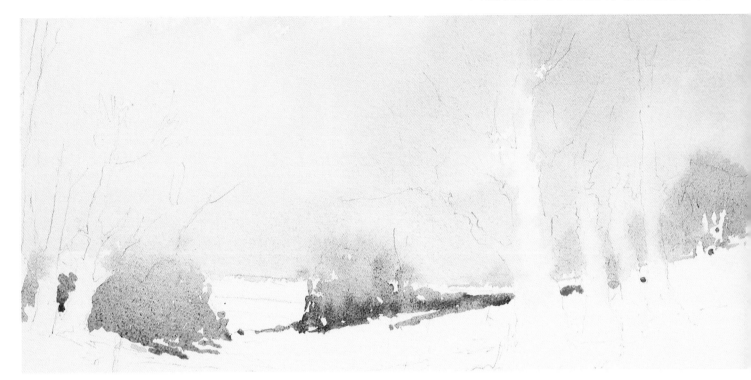

3 Adding blue and a little raw sienna to the purple mix, I used the side of a No. 6 round brush to show the background trees on the right, blending in at the top with darkish edges below. To soften the edges I dabbed off the colour, then created the negative shapes of the trunks by painting foliage behind. Going back to the No. 14 brush, I applied burnt and raw sienna below the sky colour on the left, then blended some ultramarine into the edge of the trees. I again used the side of the brush to apply a mix of ultramarine and cadmium yellow to the central area, adding some burnt sienna behind the trees and more ultramarine to darken the bottom of this area; the strong colours contrasted with the sky area, and the patches of unpainted paper depicted the snow.

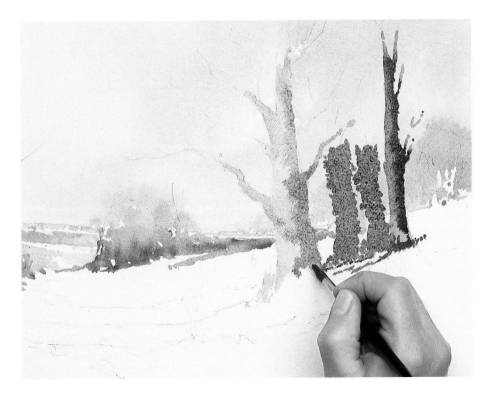

4 I used the side and tip of the No. 6 brush to apply an ultramarine/alizarin crimson mix for the line of distant hills, adjusting the tonal value as I went along and leaving white to suggest snow on the distant fields further back. I used burnt sienna and ultramarine blue to paint in the tree shapes on the right. To suggest the almost-silhouetted shape and some of the branches on the right, I used a mix of burnt sienna and ultramarine, and added some crimson for the next shapes, keeping these trees more loose and varied. While this was drying, I darkened the mix for the shadow side and applied raw sienna for the tall central tree, dabbing off to show the side on which light was falling.

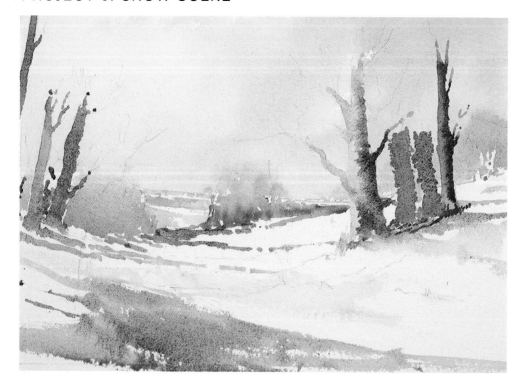

5 Using raw sienna and cadmium yellow, I started to paint the left-hand trees to give the basic shapes, but not the branches. I added ultramarine and alizarin crimson in a light, bluish wash for the shadows coming in from the left, with the texture of the rough paper creating a dragged effect. While this was still wet, I darkened the mix, then moved across the picture to add the shadows on the right. For the lighter shadows, I applied, and then dabbed off raw sienna.

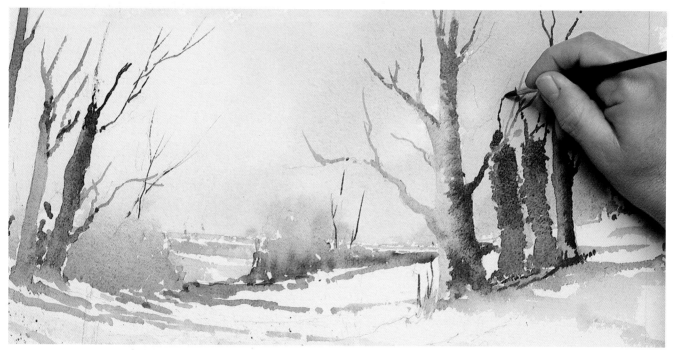

TIP

When painting shadows on snow, use the direction of your brushstrokes to determine the contours of the land.

6 I loaded some ultramarine on to a stiff flat brush and flicked it off into the wet shadows and on to the white paper at the bottom left-hand side to add texture, then let the painting dry. I switched to a No. 4 brush and a dark blue-purple mix for most of the branches and for blending in the colours already applied. Here, I was looking for variations of colour, and mixed in the colours already painted – for example, more raw sienna for the yellow tree, still leaving the finest twigs until later.

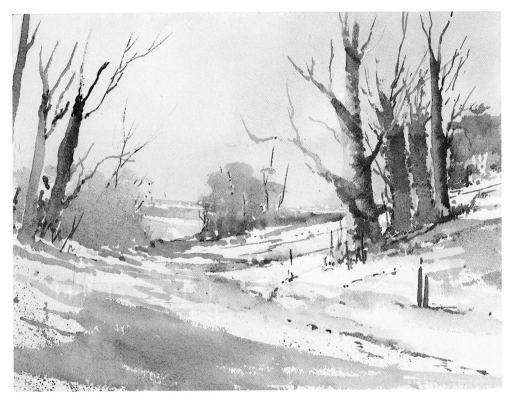

7 I added further shadows and twigs around the base of the trees, then applied the purplish shadows cast by the branches of the brown tree, and more twigs and tufts in burnt sienna towards the right-hand foreground against the white of the paper, to contrast with the ultramarine directional strokes. I strengthened the shadows at the front and dabbed them back, then used the side of the No. 14 brush to reinforce the shrubs and distant clumps of trees, using stronger versions of the mixes already used.

8 I used a No. 4 rigger brush with a blue/purple mix for the smaller twigs, working loosely and not trying to be too precise; the twigs on the left-hand side were quite dark. I also looked for more shadows on the right-hand trees to provide a basis for light and shade effects. Having dried the No. 14 brush, I dipped it in a raw sienna/cadmium yellow mix and added the foliage on the left-hand trees. I then let the painting dry completely.

TIP
Be prepared to adapt your colours to create the correct tone as you go along – as long as you don't overdo your work, you don't have to stick to my suggestions.

9 Using soft pastels, I applied Naples yellow across the lightest part of the brown tree, then a little raw umber in the middle clump and on both left-hand and right-hand trees. I applied some orange to the brown tree and left-hand clumps for strong contrast, then added little marks of olive green and grey across the trees, before putting green into the foreground. To finish, I returned to the watercolours, adding last marks with a No. 4 rigger and a red/brown mix almost dry-brushed to the fence in the central area, and added a little more spattering with the flat brush.

Rocks and ravines

By now you can probably understand how important blue/purple colours are to me. As opposed to the previous snow scene, here I used the colours not to create cool shade, but to show the shapes of the rocks many miles in the distance of the Grand Canyon, and to create impact combined with the orange colour of the rock strata in the mid-ground and foreground. I drew the scene as a sketch and added some colour notes.

The amount of sky is minimal, as it is unimportant to the atmosphere. I felt that this scene needed to be painted in dense and solid colours to suggest the heavy rocks of the canyon. This presented some difficulty, as I also needed to lighten the distance and bottom of the canyon to represent the different aerial perspectives. The whole scene is a constant change and counterchange of colours – lights against darks.

MATERIALS

BRUSHES
No. 14 round
No. 8 round
No. 4 round
No. 3 round

PAPER
Saunders Waterford
NOT 410gsm
(200lb)

FINAL PAINTING
355 x 280mm
(14 x 11in)

PALETTE

Ultramarine	Raw sienna	Cerulean blue	Light red	Alizarin crimson	Cadmium yellow	Burnt sienna	Cobalt blue	Cadmium red	White gouache

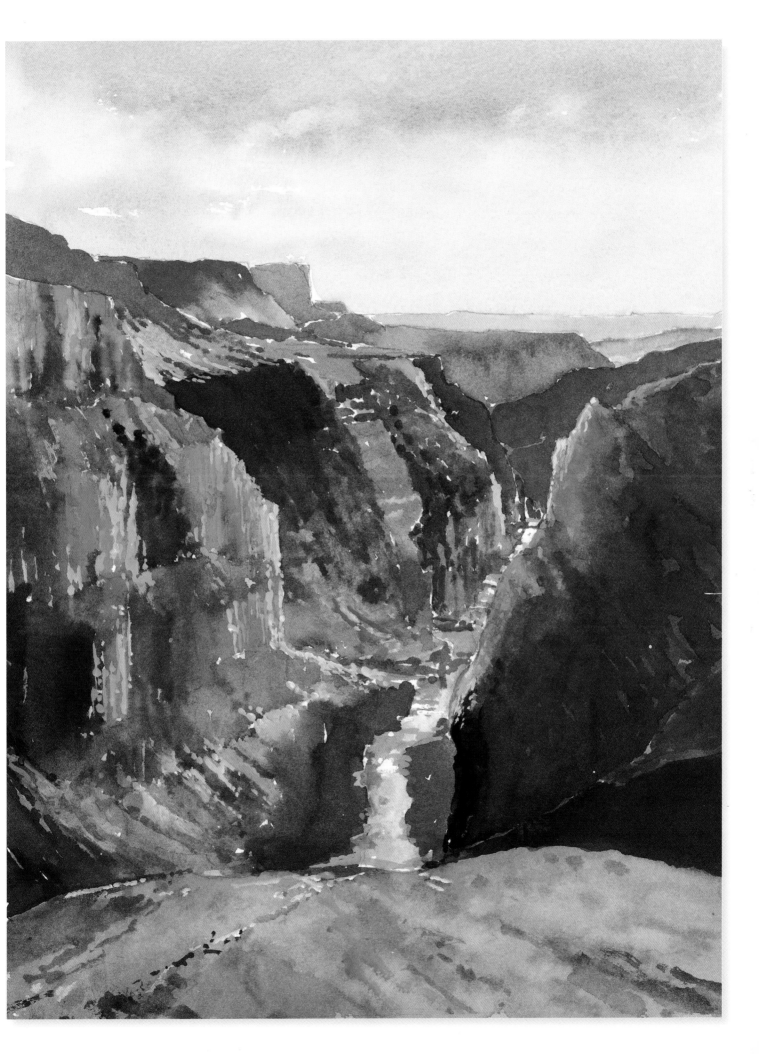

1 For the initial drawing I concentrated on making sure that the sense of depth and distance was correct, and that the relationship between the horizon line (my eye line) and the higher rocks on the left was accurate.

2 With a No. 14 brush I painted a very diluted ultramarine wash at the top of the sky, then applied a mix of raw sienna and cerulean blue plus a little light red at the very base of the sky, dabbing out the wet paint for the light clouds and changing the direction to create movement as I did so. I let this stage dry completely.

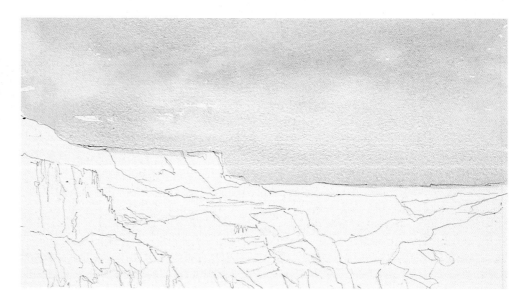

3 | For the far distance I applied a mix of ultramarine and alizarin crimson with a No. 8 round brush. For the middle distance I adjusted the proportions of the same colours and dabbed the edges to blend them. I added increasing amounts of raw sienna to make the mix more grey – the strata of the rocks are not solid blocks of one colour, but have variation and some texture. I used almost pure raw sienna for the yellow below the blue.

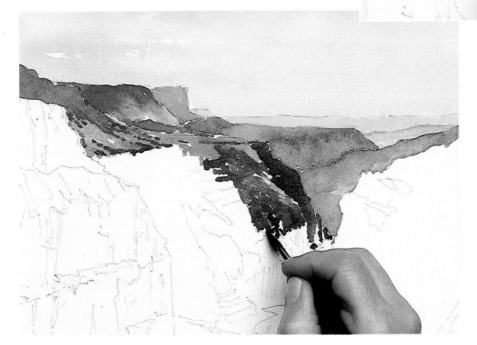

4 | I continued to use the same colours throughout the distance, just changing the intensity, dilution and proportions and working wet-in-wet with a wash, then dropping in the variations to blend back into the wash. I softened the edges by dabbing them with a tissue. For green, I added cadmium yellow and ultramarine, then added raw sienna for the next layer, interspersing this with a yellow/brown variant before blending into it from the top with ultramarine. I applied quite a dark mix of burnt sienna and ultramarine into the lighter areas to define contours and direction.

5 | I brought the green mixes down into the valley, using the brushstrokes to suggest the angle and depth, and adding burnt sienna to soften the colours. Having got to this stage, I decided that the tonal value of the middle ground to the right was too light, so I used ultramarine and burnt sienna to darken it. To bring the central valley section down, I applied the blues and greens over each other in turn to blend the mixes on the paper, and then painted the dark fissures on to semi-dry washes, looking for patterns of hard and soft edges. I took a break to allow the painting to dry thoroughly.

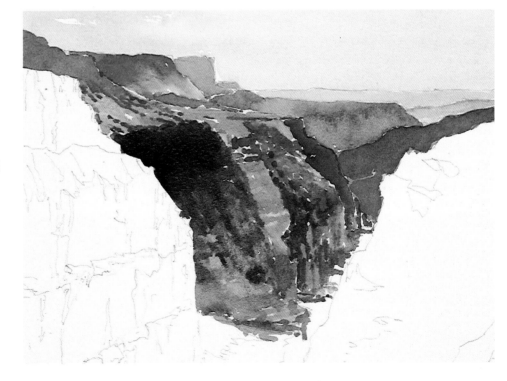

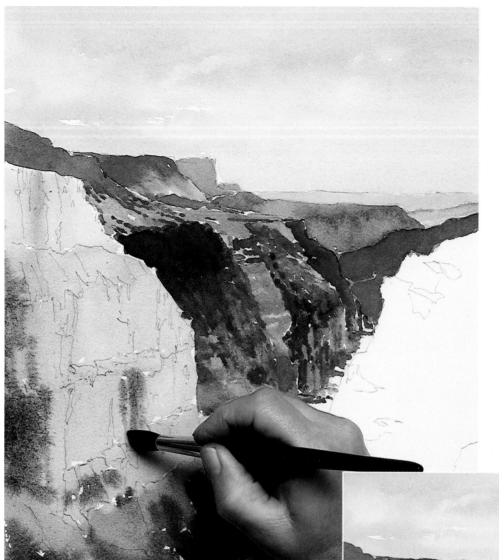

6 I applied diluted mixes of raw sienna and light red for the very.light washes on the left, dropping in light red and the green mixes with the No. 14 brush while these were still wet. Working between the washes all the way down the left to create the layers of the strata, I continued to keep everything light so that I could build on it later. I added some ultramarine as I went lower.

TIP

On a project of this type, when the main tonal blocks are in place, take a break and look at the painting again, from close up and far away, and really think hard about the finish you want to achieve..

7 I mixed burnt sienna and ultramarine with some cobalt blue for the blue-grey rocks on the right, and added some raw sienna to lighten this in parts. I applied quite bold washes, with lots of raw sienna and green at the very bottom, dabbing off to soften the edges of the colours.

8 | For the first strong orange I mixed light red, cadmium yellow and cadmium red, applied this in vertical strokes using the No. 8 brush, and added burnt sienna and ultramarine for the darker verticals, dabbing the paint off to keep the edges soft. Then I brought in the green layer below, using the brushstrokes to indicate the angles, and lightly applied a more diluted orange wash below that.

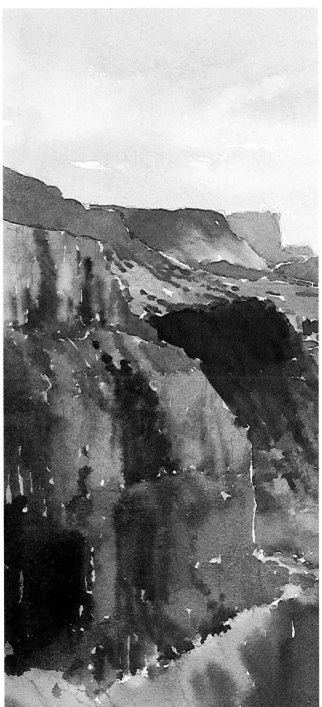

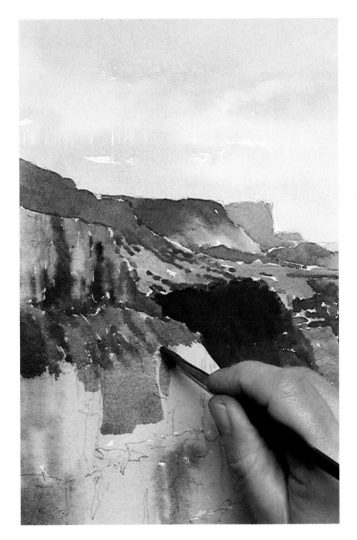

9 | To show the light and shade on the darker areas of this layer I added quite contrasting tones of alizarin crimson and ultramarine separately. Although I worked fairly quickly to achieve the softened effect, I made sure that I had some control over the amount to which each paint could bleed and blend. I then added more ultramarine for the shadow areas and worked through all the blue, brown and green mixes, adding to them as required.

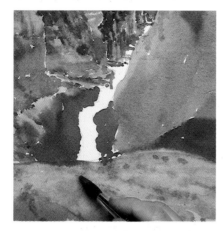

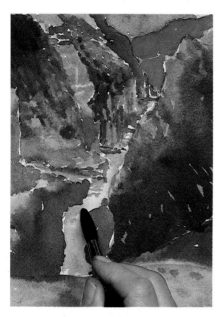

10 I created soft blue edges at the bottom of the cliff by putting on very wet washes and dabbing them off immediately. I applied a raw sienna wash over the foreground and then used the tip of the brush to drop in darks while this was still wet, and to apply contour strokes of light red and then burnt sienna.

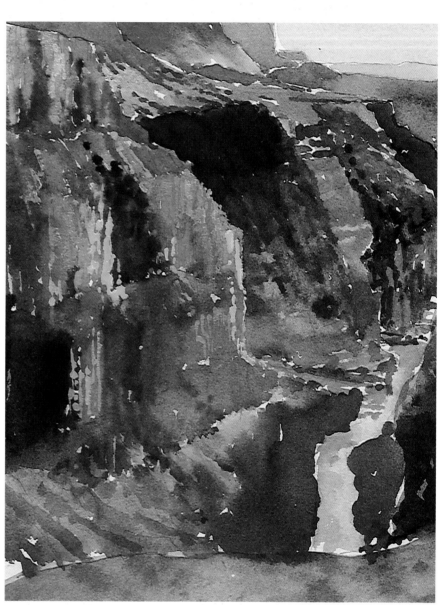

11 On the right-hand hillside, I started with a weaker version of the left-hand orange, moving into the greens and blues, then used crimson on the green to flatten and darken it before I dabbed it off while it was quite wet. I then used cobalt blue quite diluted for the river, dabbing it off for effect and adding more blue for reflections.

TIP

Leaving little bits of white throughout a picture can keep in the sparkle and help to stop a painting from going dead; undercoat washes can have the same effect.

12 I added cadmium yellow and light red to white gouache to bring out the lightest parts of the left-hand orange areas, and applied this with a touch more cadmium red in the mix, using a No. 4 round brush. Working into the shaded areas to show the vertical parts of rock that really caught the light, I aimed to vary the amounts of colours for impact on the scene. I then added green mixes to white gouache, so as to put lighter parts into the green areas.

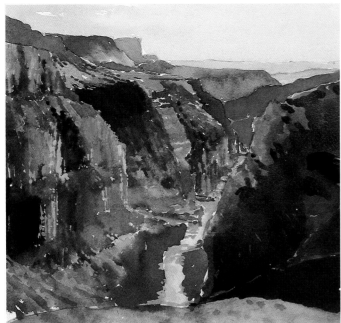

13 To add sparkle to the river and to change its shape a little, I mixed ultramarine with white gouache, going over some bits of white paper to tidy it up. Then I used a very light green with gouache to paint in the highlights on the top green ridge and drop to the river. Using the No. 14 brush I applied a mix of cadmium yellow, ultramarine, alizarin crimson and burnt sienna for the very darkest wash over the right-hand foreground, and a very diluted version, dabbed off, for the darkest bits in the area above that.

TIP

When using white gouache mixed with pigment, remember that it will dry darker than when applied, so apply it quite light and experiment until you feel confident.

14 While the washes were still wet, I used the No. 4 brush with the green/ gouache mix to bring the darks up into the light. Then I applied small marks of burnt sienna and ultramarine to the foreground contours and furrows. I applied a light green wash of cadmium yellow and ultramarine to take off the deepest blue towards the horizon, and then put a mix of orange and white gouache in front of it. I used quite a darkish green mix of ultramarine and cadmium yellow to take out the last white at the bottom, dabbing the edges, then I applied an ultramarine and burnt sienna mix to bleed back into the areas above, washing into the original colours for strength and depth. Using a No. 3 round brush, I applied gouache-and-pigment highlights throughout the picture, aiming to keep them understated and unobtrusive.

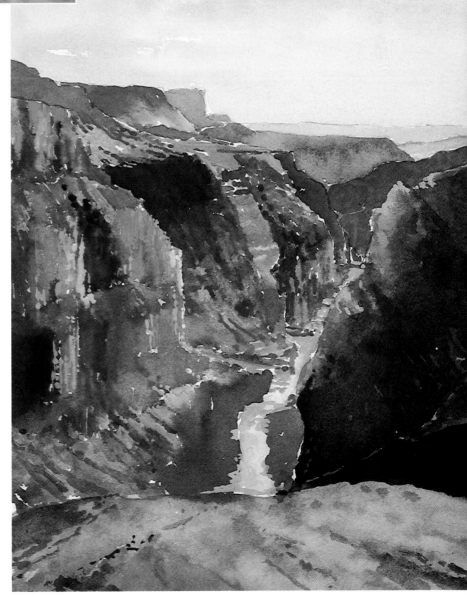

Boats

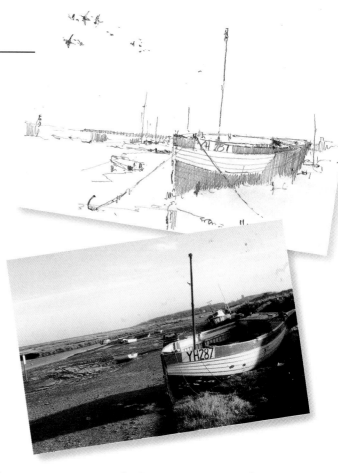

The last project showed little of the sky, but this one features the sky as the main element of the painting. Where I live in north Norfolk, the skies are a very dominant feature and are reflected in the mud flats and expanses of water. This part of the coast is well known for its flocks of geese, and to get across the feeling I was after I thought it was appropriate to use geese as part of the landscape.

The light washes here were laid on to depict what is really a skyscape, and the low horizon suggests a wide-open expanse of flat ground. The treatment needed to be kept unfussy to capture the feeling of space in the landscape at Morston.

MATERIALS

BRUSHES
No. 14 round
No. 4 round
No. 3 rigger

PAPER
Saunders Waterford
NOT 410gsm
(200lb)

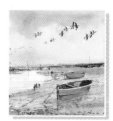

FINAL PAINTING
280 x 330mm
(11 x 13in)

PALETTE

Ultramarine	Cobalt blue	Cerulean blue	Raw sienna	Alizarin crimson	Cadmium yellow	Light red	Burnt sienna	White gouache

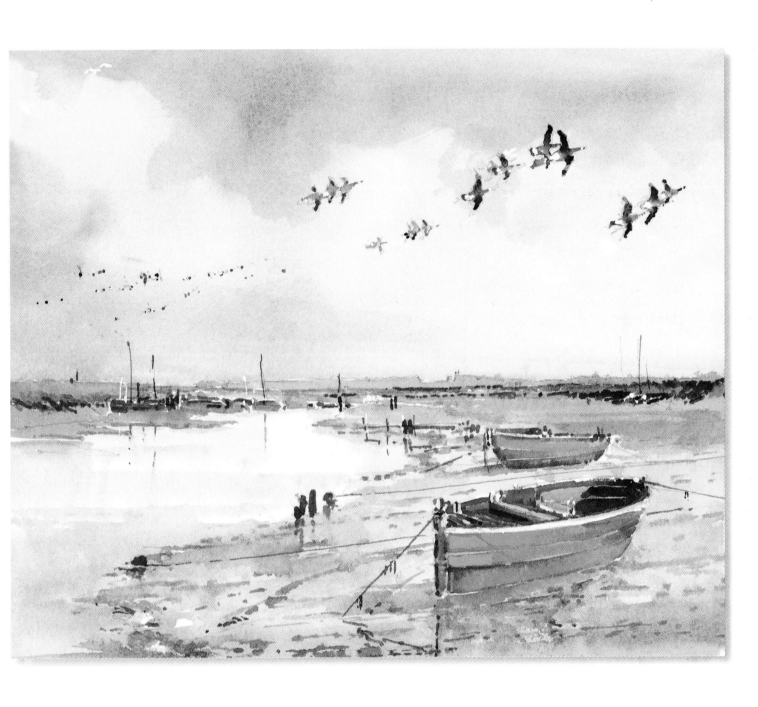

1 | Although the sky is predominant, I positioned the horizon just below centre, as the major focal point of the painting is the boat in the foreground. It is important that this focal point is off centre, but the composition is balanced by the water moving into the central area from the left.

2 | To lay in the sky I used a No. 14 round brush and ultramarine, cobalt blue and cerulean blue to achieve aerial perspective. For the clouds I applied raw sienna, finishing with a mix of ultramarine and alizarin crimson on the horizon.

3 | I next applied a light wash of ultramarine to the water area and pulled it down with some kitchen roll to ensure it was lighter than the sky. Before this dried I darkened the water a little to the foreground and dragged down the tissue again (**see inset**). Because at this stage I was working on covering the paper with light, translucent washes, I painted raw sienna around the boats and then a purplish mix of ultramarine and alizarin crimson colour in the foreground, dragging down some of the paint around the foreground boat.

4 | Using a mixture of ultramarine blue, cadmium yellow and raw sienna, I painted in the marshes to the left and right in the distance, changing strength in places to avoid the finish being too flat. While waiting for this to dry, I applied a combination of cerulean blue and ultramarine, a purple mix of ultramarine and alizarin crimson, and light red to the base of the foreground boat, repeating this below the boat to indicate reflections in the mud.

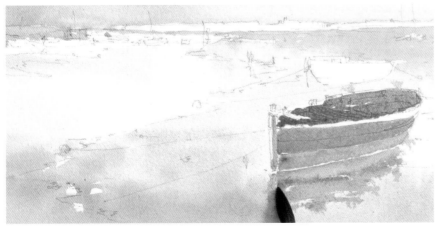

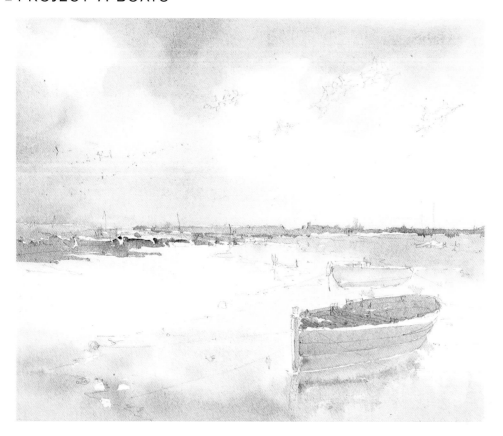

5 I painted the second boat with pale cerulean blue, and then painted into the marshes from the left with the purple mix, and dropped in some red and blue for the distant boats. I finished this part of the project by painting the distant horizon with a pale wash of ultramarine and alizarin crimson, and then allowed all the washes to dry.

TIP

Use the time spent waiting for washes to dry to clean your brushes and change your water; you can also clean redundant colours and washes from your palette.

6 With a No. 4 round brush, I used a mixture of ultramarine, cadmium yellow and raw sienna to paint the grass bank on the right, lightening the colours in the distance. I then applied the same colours to the marsh area on the left. Using a stronger mix of raw sienna I overlaid the marsh areas, again washing off into the far distance, and used the same wash for the middle distance, leaving some of the original wash showing. I darkened the colour where the sand hits the water line.

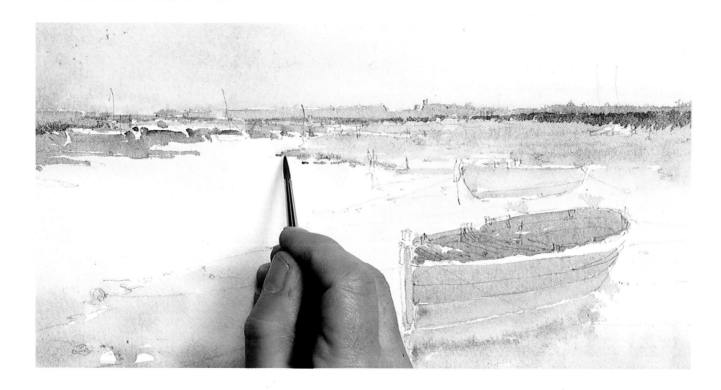

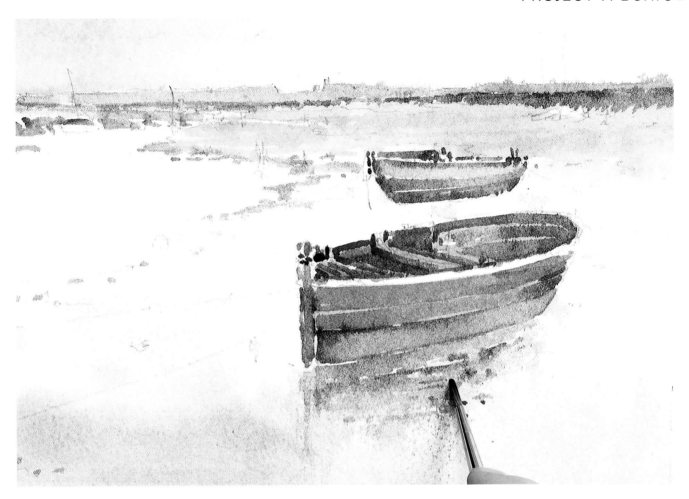

7 | I added a mix of burnt sienna, raw sienna and ultramarine to the foreground areas, then strengthened the smaller boat with cerulean blue and painted the details using a mixture of burnt sienna and ultramarine. Switching to the foreground boat, I added combinations of burnt sienna and ultramarine, darkening the inside and strengthening the original blue colour and the light red at the bottom of the boat. To stop this old boat from looking too pristine, I ran in some darks while the paint was still wet, allowing them to merge. I then overlaid the reflection of the boat in the mud and dragged the washes down with some kitchen roll to soften the colours.

8 | With the same brush I strengthened the distant boats – the tip here is not to try to paint accurate boat shapes, but to just suggest the form and let the viewer's eye add the details.

9 Using alizarin crimson added into a green mix of ultramarine and cadmium yellow, I strengthened some of the greens to the right of the painting and added the bushes and shrubs on the edge of the marsh, then painted the same mix on to the edge of the marsh on the left-hand side. To create the shadows cast by the boats on to the mud I used the purplish mix, making sure to show the direction of the slope towards the water. With a mixture of burnt sienna and a touch of ultramarine I indicated lumps of mud in the foreground.

<div style="border:1px solid">

TIP

Make sure you leave some of the original washes showing in the final work, as this will bring light into your paintings.

</div>

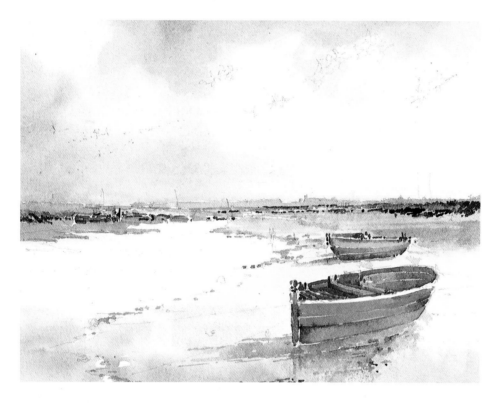

10 Switching back to the No. 14 brush, I deepened some of the mid-browns with raw sienna, leaving behind the original wash in places. While this was wet I painted more purple mud into the foreground with a slightly stronger mix of ultramarine and alizarin crimson, blending this into the raw sienna. I changed to the No. 4 brush and used a mix of burnt sienna with a touch of ultramarine blue to add mud marks in the foreground; these ran into the purple washes to create soft marks and avoid any hard edges.

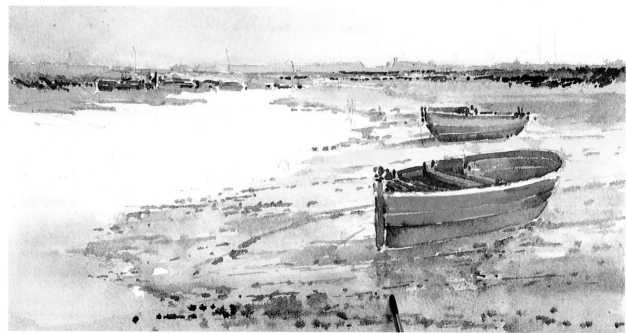

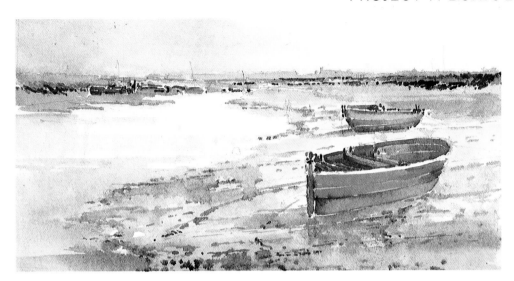

11 Using the No. 14 brush and a pale mix of ultramarine, I added a wash into the water area to suggest depth and movement, deepening the colour to achieve a better perspective effect.

12 To apply the initial shapes of the geese I used the No. 4 brush and a mixture of ultramarine and burnt sienna. While this was wet, I made darker marks on the nearest geese with a mixture of white gouache and a touch of the dark mixture and then allowed this to dry. Next I painted the white underside of the geese and used white gouache to start the final marks on the boats, then used burnt sienna and ultramarine for the landing-stage posts. To finish, I painted the shadows on the foreground boat with a deeper mix of ultramarine and alizarin crimson.

13 At this point I switched to a No. 3 rigger brush to indicate the masts of the boats, mooring lines, bits of weed and final details, and introduced a different colour by suggesting the mooring buoys with a touch of alizarin crimson. I used the same brush to add highlights sparingly with white gouache (see page 87).

TIP

When painting still water, make sure that you show the reflections of any objects standing in or above the water.

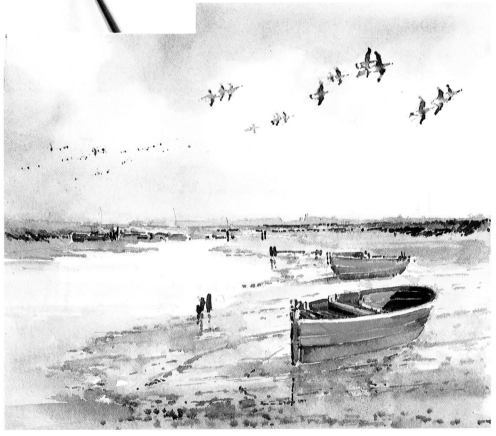

Coastal village

I have visited this part of Great Britain, along the north Yorkshire coast, a few times. Walking from the coast into Robin Hood's Bay you are met with this view, which looks down to the coast with the village nestling into the cliffs that form the backdrop to this painting. The whole painting is not just to do with tones, but also with the intricate perspective of the groups of cottages.

In this painting I took what is perhaps a slightly unusual view from all the brilliant scenes that were available, because it portrays for me the essence of this area along the coast, and not just the village itself. I did not therefore attempt to slavishly copy the cottages exactly as they are; instead, I relied on sketches and memory, and used them as a prop to capture the atmosphere I was seeking.

MATERIALS

BRUSHES
No. 14 round
No. 8 round
No. 4 round
No. 3 rigger

PAPER
Saunders Waterford
NOT 410gsm
(200lb)

FINAL PAINTING
405 x 305mm
(16 x 12in)

PALETTE

Cadmium yellow	Ultramarine	Raw sienna	Alizarin crimson	Burnt sienna	Cobalt blue	Light red	White gouache

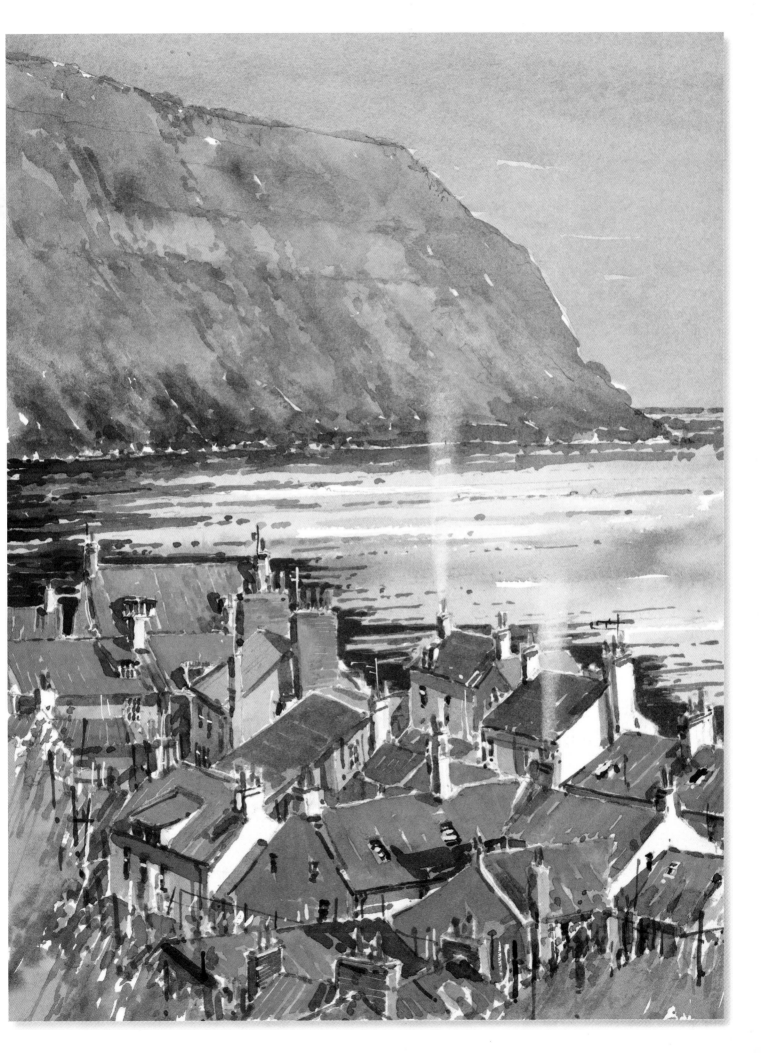

1 While visiting the village I drew a few sketches on the spot, and led into this painting with a drawing of the final composition that was taken from the sketch on page 94. It is imperative to the whole composition to get the main perspective lines as accurate as possible.

2 With a mixture of cadmium yellow and ultramarine I started a loose green wash on the top of the cliffs, working wet-in-wet with a No. 14 brush. I then added raw sienna into that colour and dragged this back into the previous colours before using a little green to soften it. I painted a purple mix of ultramarine and alizarin crimson back into the wash to create distance. I varied these colours all the time, letting them run and mixing them on the paper.

3 Before the colours dried, I mixed burnt sienna and raw sienna and painted back into the cliff, working freely and quickly. I used a darker green for the bottom of the cliff, then applied some more purple, only partially cleaning the brush, as this helps to blend the colours. Then I dabbed off the wettest parts with a piece of kitchen roll to soften them before leaving the paint to dry.

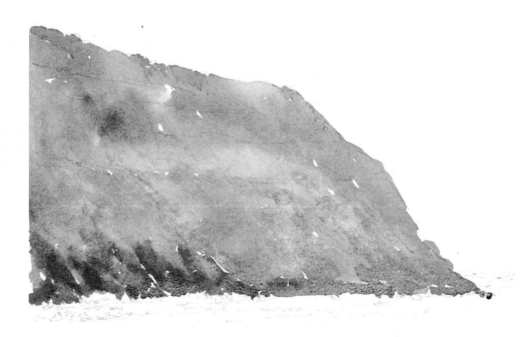

4 │ Using cobalt blue and an ultramarine for translucency, I made a flat wash for the sea, right down to the houses, leaving some horizontal stripes of white, then added darker bands of blue, damping them off again. Because I painted this all in one go, it makes a good impression of shallow water.

TIP

Always mix slightly more colour than you think you need.

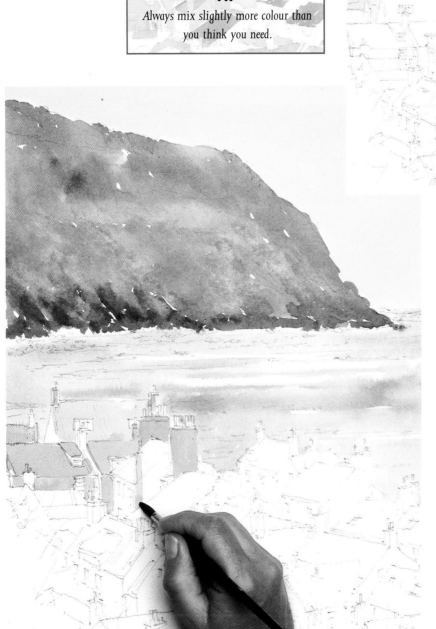

5 │ To provide a base colour for the sky, I painted an even wash of raw sienna over the whole sky area. While this was drying, I decided to block out the great jumble of buildings. These are all different colours and tones, so I started by painting the clay roof tiles using light red mixed with cadmium yellow with a No. 8 brush, keeping the mix on the pale side.

TIP

Where you have a detailed foreground, as in this painting, keep any sky areas fairly flat, without much detail.

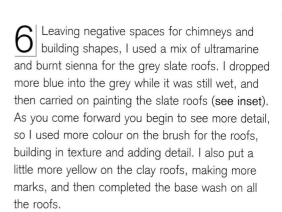

6 | Leaving negative spaces for chimneys and building shapes, I used a mix of ultramarine and burnt sienna for the grey slate roofs. I dropped more blue into the grey while it was still wet, and then carried on painting the slate roofs (**see inset**). As you come forward you begin to see more detail, so I used more colour on the brush for the roofs, building in texture and adding detail. I also put a little more yellow on the clay roofs, making more marks, and then completed the base wash on all the roofs.

TIP

When painting slates use horizontal strokes, and use vertical strokes for clay roof tiles – this acts as a kind of visual shorthand.

7 | Using raw sienna I went back into some of the walls as the colour on the roofs dried, making sure the shadows were on the left as light was coming from the right. I used cobalt blue and dirty water to paint the shadow side of any white buildings, and then mixed burnt sienna and ultramarine for the chimneys on the shadow side. I went back to the green mix, added a bit more cadmium yellow, put a wash over the shrubbery and dropped in some darker greens.

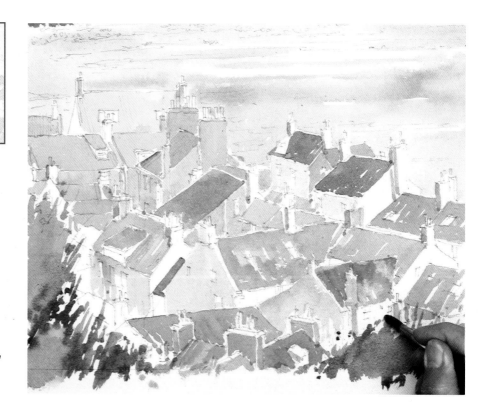

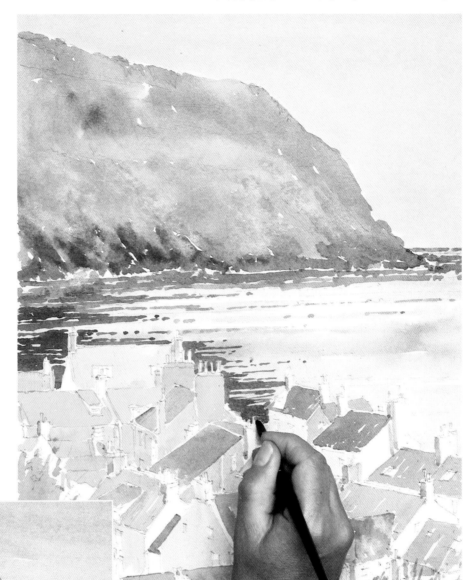

8 | Using a No. 14 brush I put a fairly flat, light wash of alizarin crimson on the sky, which brought it into line with the colour of the clay roof tiles and unified the painting. With a No. 8 brush I painted the lichen at the bottom of the cliffs, using a mixture of green, cadmium yellow and cobalt blue, leaving out the area of the rocks. As I came forward I darkened and toned back the water on the horizon with a purple colour of cobalt blue and crimson. I then darkened the green at the base of the cliffs in horizontal bands using the green mix, but with more pigment.

9 | I painted a pale wash of ultramarine over the sky area, leaving some of the red showing through. While that was drying I put in some marks for windows using ultramarine and burnt sienna, keeping the mix on the blue side. I next used light red for the chimney stacks – however, because this is a long-distance shot of the village, I didn't want to put in too much detail. To help the composition I added vertical grey punctuation marks for the windows and chimney stacks with a No. 8 brush.

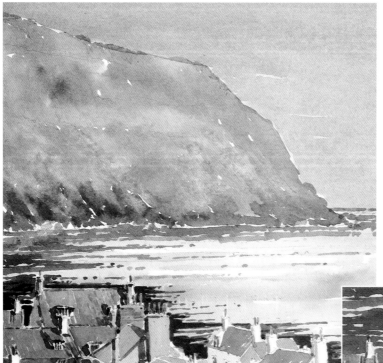

10 I next concentrated on the top left area of the buildings, using light red, ultramarine and burnt sienna, and gradually changed colour using a combination of light red and cadmium yellow, and adding marks with a No. 8 brush (**see inset**). I used a mix of ultramarine and alizarin crimson for shadows but not too dark. I then mixed ultramarine and cadmium yellow to make a really rich green, added a touch of crimson to darken it, and darkened the green adjacent to the buildings to get the right tonal effect and make the light work better.

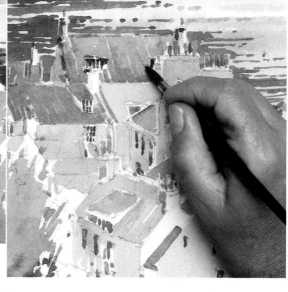

11 I mixed stronger pigment colours for the roof, washing them off occasionally as well as adding ultramarine to get slightly darker effects. As I came forward I left more marks to indicate details. Adding ultramarine and a green softened the terracotta a bit and gave an older appearance to the roofs. I then painted back into the grass without showing too much detail, before going back on to the grey slate roofs using ultramarine and burnt sienna in horizontal strokes, as opposed to vertical strokes on the clay-tile roofs.

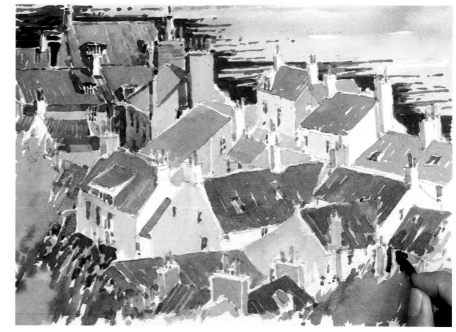

12 I now put deeper washes of cobalt blue with a little burnt sienna on the shadow side of the building; this was also a good foil to the red roofs. I didn't paint every bit, as this gave an aged effect. For the chimney stacks I used burnt sienna and cobalt blue, then switched to a No. 4 brush to do the windows, giving them a little more detail with a finer line. The windows are still marks, however, and I hinted at a suggestion of brickwork to bring the eye forward again.

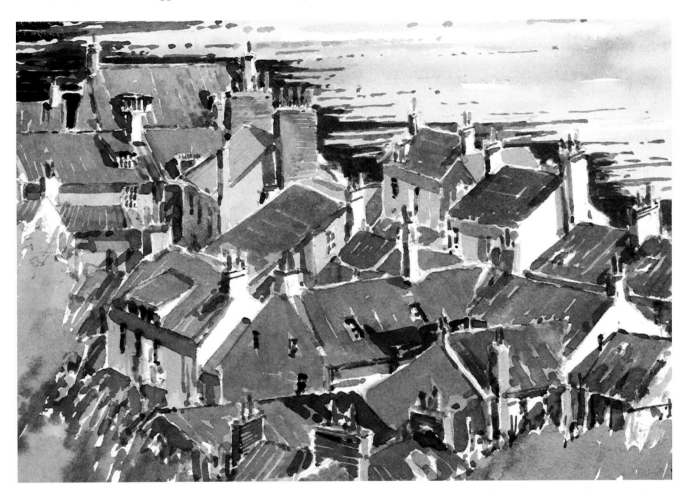

13 I went back into the distant cliffs, which needed some more definition. I put a bit of depth into the cliffs by changing to a No. 4 brush to suggest crevices and sandstone. I worked across the whole area while it was still wet, adding different types of green to suggest foliage. I darkened the underside of the cliffs using ultramarine and burnt sienna, painting up from the base to soften and blend into the distance, not showing any great detail.

14 Using a No. 4 brush and a mix of ultramarine and burnt sienna, I redefined the darks of the windows, gutters and drainpipes. Painting more strongly again towards the foreground, I made marks for fences and just suggested the foreground fence posts, working very subtly and not getting bogged down. To give a hint of life to a sleepy village, and in an attempt to connect the bottom to the top half of the painting, I suggested smoke coming from a chimney by lifting the colour off with an old brush and clean water and taking the final colour off with the edge of a piece of kitchen roll (see inset).

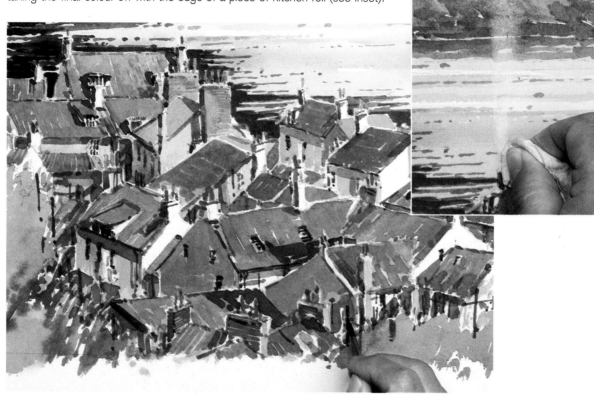

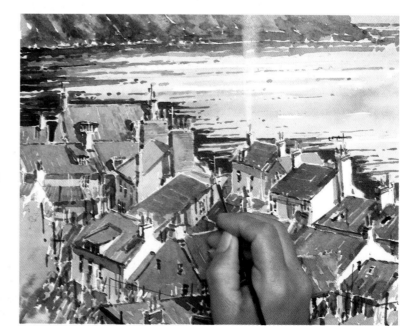

15 Although I didn't use white gouache for the smoke, as this tends to cover the background and is too opaque for my liking, I used it to put some washing on a line in a dark area at bottom right with a No. 4 brush. Again using white gouache I picked up little dots of white, to give sparkle to the painting and tidy it up – but not to overtidy. Using a No. 3 rigger I put in the posts in white, then added a little sparkle on the water and light on the TV aerials, for example, to contrast with the darks. I then placed darker marks against the light, making marks for posts and telegraph poles.

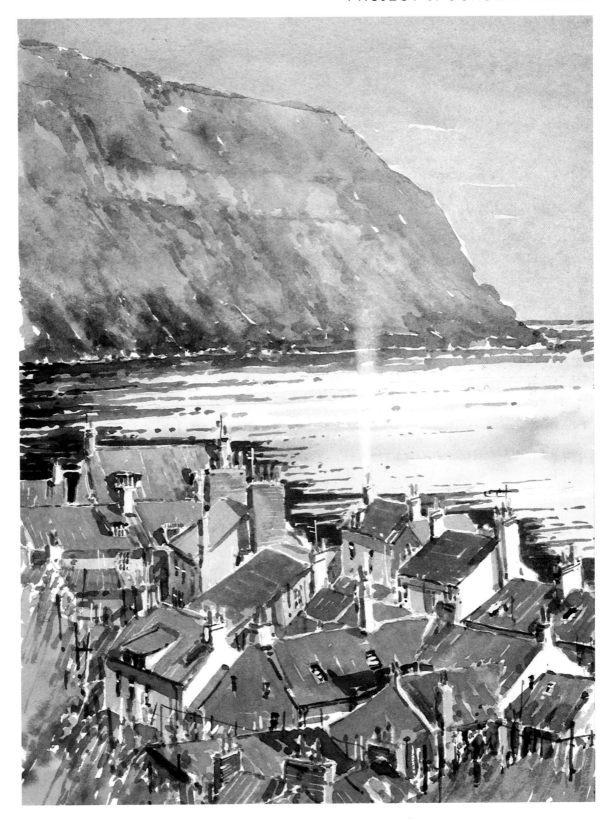

16 | Going back into the green with a No. 4 brush I painted a few loose marks, drawing back into the wash. I didn't do too much, as I didn't want the eye going to the edges of the painting. Having stepped back, I removed the paint for another, lighter plume of smoke and took it across the building, to break up the form a bit and add more interest, letting it fade out as it went into the sea (see page 95).

Project 9
Stately home

This painting shows an open landscape surrounding a large Palladian mansion at Holkham in north Norfolk, only part of which I have chosen to depict; it is intended to be in complete contrast to the huddle of fishermen's cottages in the previous project. The sketch shown here was made on location in pen and wash.

In this project I have tried to illustrate the scale of an old country house in a landscape. The flat sky serves to emphasize the yellow of the buildings and walls against the foreground greens and distant blue-greens of the trees and grass.

MATERIALS

BRUSHES
No. 14 round
No. 12 round
No. 4 round

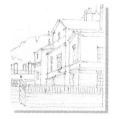

PAPER
Saunders Waterford
NOT 410gsm
(200lb)

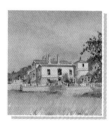

FINAL PAINTING
255 x 330mm
(10 x 13in)

PALETTE

Raw sienna	Ultramarine	Cadmium yellow	Alizarin crimson	Burnt sienna	White gouache

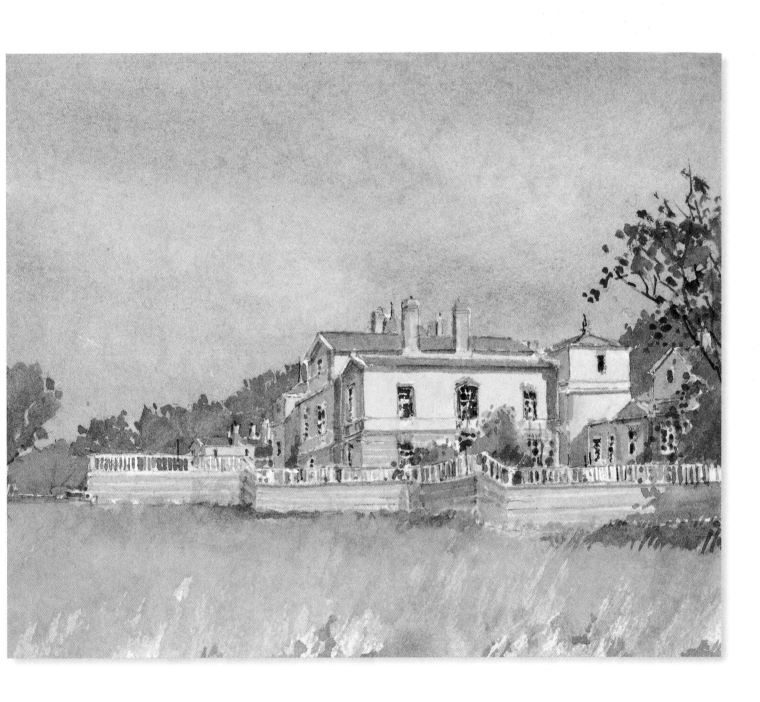

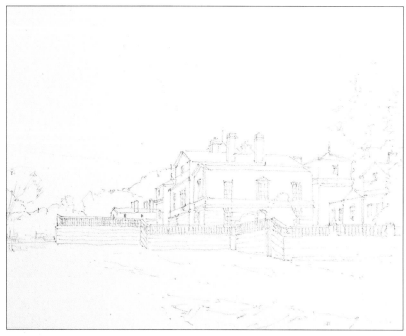

1 In the initial drawing I chose a side view of part of the house and wall against a backdrop of trees. A lot of detail was eliminated, as the drawing was intended just to reflect the hard edges of the architecture against a soft landscape.

2 Using a No. 14 round brush I put a raw sienna wash over the whole of the paper, to accentuate the soft effect, and let it dry.

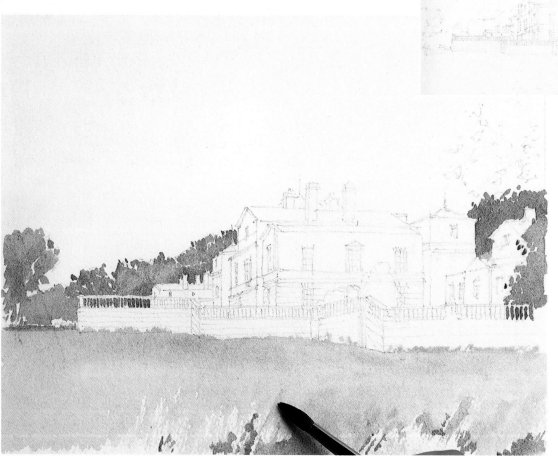

3 Switching to a No. 12 round brush and using a mixture of ultramarine and alizarin crimson, I carefully painted into the building to depict the background trees, and then added cadmium yellow to the mix to warm up the trees on both edges of the painting. With the same brush and the addition of more cadmium yellow I laid in the foreground grass area, and used a dragging effect with the side of the brush to apply this stronger colour to the base of the painting.

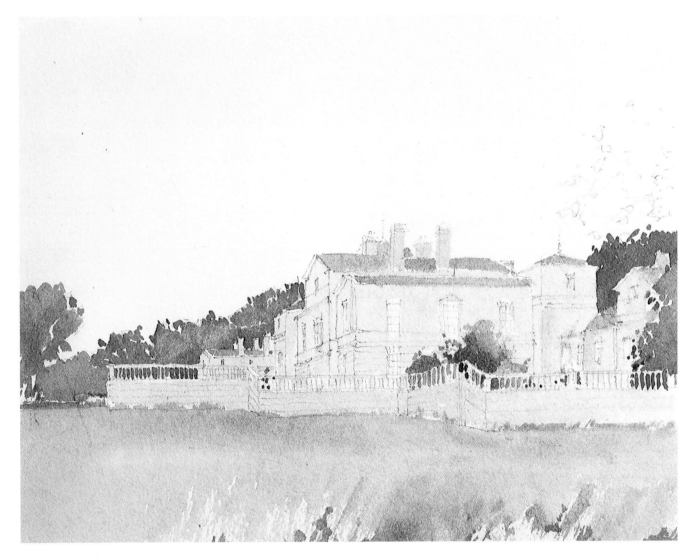

4 | Using a No. 4 round brush and raw sienna, I painted the walls of the building and the surrounding wall. I used a mixture of burnt sienna and ultramarine to apply a flat grey to the roofs, and mixed cadmium yellow and ultramarine for the bush area against the house.

TIP

Attack overlayers with confidence, but ensure you are able to see the first wash showing through when you have completed the second wash; this takes practice, as the effect may not be observed until the paint is dry.

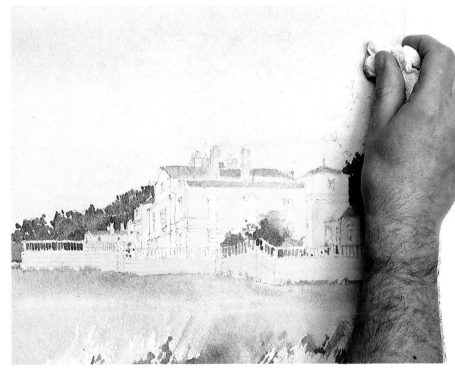

5 | To create the flat grey of the sky I used the No. 14 brush to paint the whole area, including the distant trees, with a light wash of alizarin crimson. I dabbed out some of the red with kitchen roll to produce a broken texture in the sky.

6 Using the No. 4 brush and a mixture of raw sienna and ultramarine, I painted in the shaded side of the building to create form. With the same brush I mixed and applied burnt sienna and ultramarine to suggest the windows, being careful not to overstate the detail. I then deepened the raw sienna and indicated the stonework courses on the building and surrounding wall, shading these in to show their form.

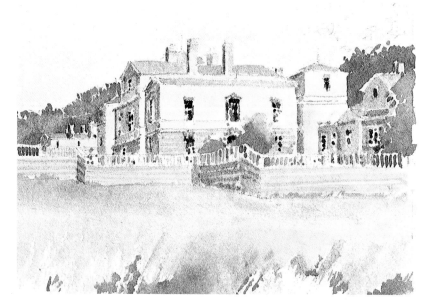

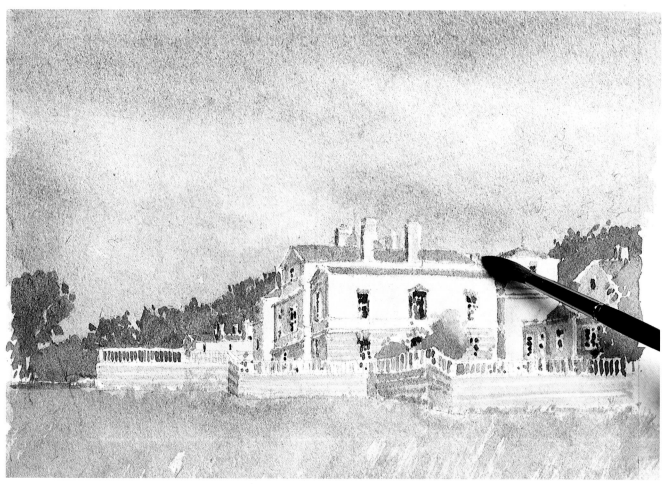

7 With the No. 12 brush I strengthened the green foreground area and again used a dragging effect to create the long grass. I then used a translucent wash of ultramarine to paint the third layer of the sky, from the top down to the building and over the distant trees, such that I could still see the previous colours through it.

8 While waiting for the paint to dry, I took the opportunity to draw back in and define the building shape with pencil.

TIP

Although drawing back into a painting in order to define details, firm up the form and reiterate lines can be very effective, don't be tempted to do this every time — be selective!

9 Using the No. 4 brush and a dark green mix of ultramarine and cadmium yellow, I painted in the tree on the right-hand side and strengthened the one underneath, and also in parts, the tree in front of the building. Changing to a No. 3 rigger brush and a dark mix, I suggested the branches on the tree on the right, and then used white gouache in very limited areas to highlight the window frames and the balustrade to the wall. I used a mix of ultramarine, raw sienna and alizarin crimson to paint the shadows on the house walls, and then added some cadmium yellow to this mix for the shadows in the grass area to finish.

Old barn

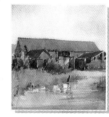

We have now come full circle, from beach huts to a barn in north Norfolk, on the way including open spaces and skies, small- and large-scale buildings and different weather conditions. Using a heavyweight paper for this project allowed me to paint wet-in-wet, and to run colours into each other for the initial base wash.

This painting encompasses many of the techniques used in the previous projects, such as sky, perspective, reflections and foliage. You could use this painting to show different effects by changing the sky and the amount of light on the building – by now you should be painting with confidence, and it can be good sometimes to go a little further and experiment.

MATERIALS

BRUSHES
No. 14 round
No. 12 round
No. 4 round
No. 4 rigger

PAPER
Saunders Waterford
Rough 600gsm
(300lb)

FINAL PAINTING
305 x 380mm
(12 x 15in)

PALETTE

Ultramarine	Cobalt blue	Cerulean blue	Alizarin crimson	Cadmium yellow	Light red	Raw sienna	Burnt sienna	Yellow ochre	White gouache

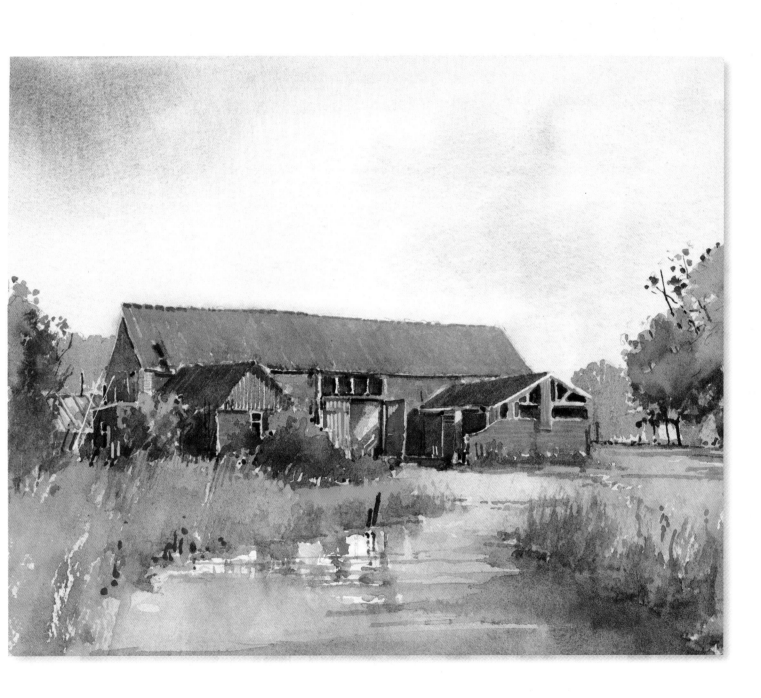

1 This drawing contains quite a lot of detail, and it was important that a fairly accurate perspective was achieved. The main building was off centre and fairly well down within the painting area, to give some emphasis to the sky.

2 Using clean water, I covered the whole paper quite liberally using a No. 14 round brush. When the gloss of the water had evaporated, I started on the sky, using my normal progression from top to bottom of ultramarine, cobalt blue and cerulean blue, and finishing with a purple mix of ultramarine and alizarin crimson at the base. I then added pale green to the foliage areas by using a mixture of ultramarine and cadmium yellow, varying the mix as I went along. For the roof of the barn, I used a mixture of light red and cadmium yellow.

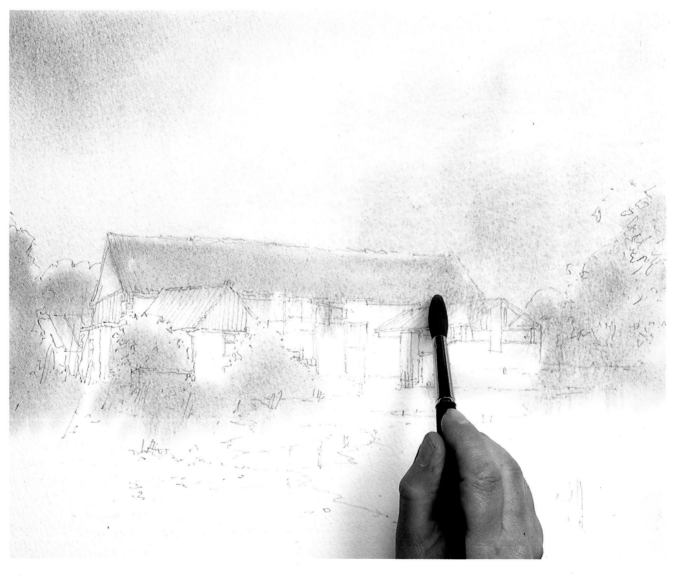

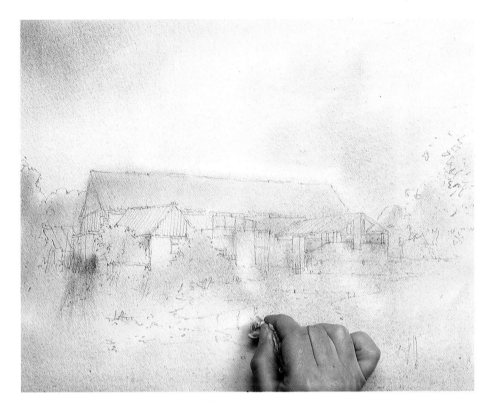

3 I placed mixtures of raw sienna, blues, purples and burnt sienna over the whole painting down to the bottom edge, dropping in colours for effect. While the washes were drying, I used a piece of kitchen roll to blot any unwanted runs and introduce areas of light, before allowing the whole painting to dry.

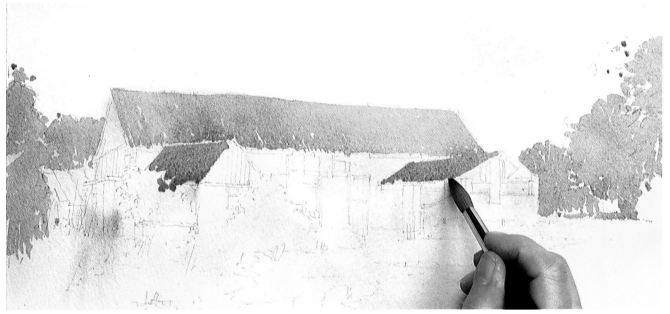

4 I switched to a No. 12 round brush, and painted in the distant trees using a mixture of ultramarine with a small amount of alizarin crimson and burnt sienna. For the green trees on either side of the painting I used a mix of cadmium yellow and ultramarine, making sure I let the sparkle of the original washes come through in places. I next mixed up a base of light red with some cadmium yellow, and painted in the main roof and the roofs of the extension to the barn. While this was drying, I dropped in touches of the green to dull the roof in places and provide texture.

5 I felt it was important to leave glimpses of the background coming through to show texture and form. Combinations of light red mixed with ultramarine were used for the extension walls, ultramarine and burnt sienna for the end of the barn, raw sienna for the main building form, and cerulean blue for the doors.

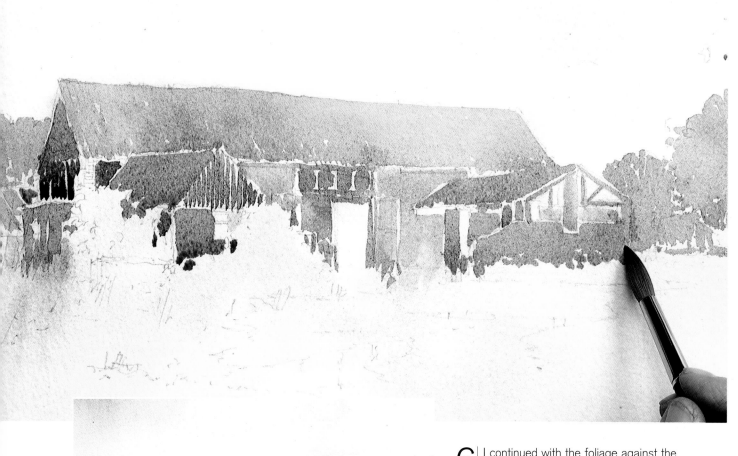

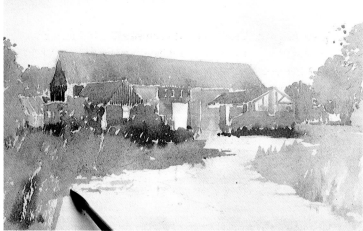

6 I continued with the foliage against the building using a green mix of cadmium yellow and ultramarine, changing the mix to achieve different depths of colour and ranges of greens.

7 With the same colours I painted the grass areas in the middle ground and foreground, at times using the side of the brush to achieve a dragged effect. While this was wet I added darks into the bottom of the grass and then laid a wash of yellow ochre to the pathway, adding in reflections of the barn to suggest puddles.

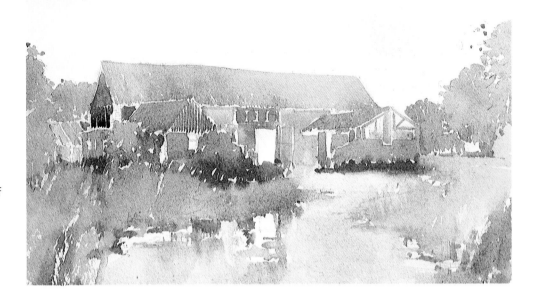

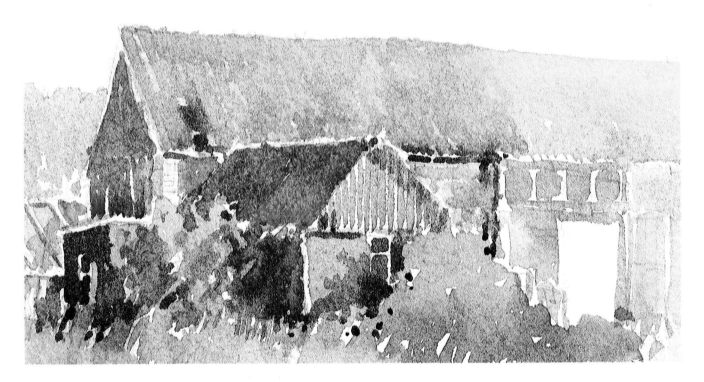

TIP

Once you have covered the paper, allow it to dry, and then stand back and look at your tonal values; you won't be able to change them when you have started on the details.

8 Using a No. 4 round brush I darkened the tree on the left-hand side and indicated an old greenhouse. I then used a light grey made up of cobalt blue and burnt sienna for the shadow cast from the barn. I darkened the roof extension with ultramarine and burnt sienna, and used the same combination for the side of the barn. I added a mixture of light red and ultramarine to darken the shaded roof extension. Using the side of the brush I darkened the green of the bush beside the extension, leaving some of the original colour showing through at the top. I added the window to this using a mixture of ultramarine and burnt sienna, and then placed in a shadow cast from the bush against the wall. I applied raw sienna to the main barn up to the doors, and then painted light red on the roof to the same point, dropping in some ultramarine to create texture. With a mixture of ultramarine and burnt sienna I indicated the gutter and a hole in the roof.

9 | I continued the main roof with a mix of light red and cadmium yellow, and then painted the panelled area with ultramarine and burnt sienna, switching to a purple mix of ultramarine and alizarin crimson in the doorway area, dabbing this off. I painted the right-hand extension to the barn using the same colours with the addition of ultramarine and burnt sienna to suggest the interior of the extension and shadow across the main barn wall. After applying cerulean blue on the doors, I painted into the right-hand trees in a similar fashion as before, and suggested trunks with a mixture of ultramarine and burnt sienna. I carefully left the initial wash to show the roof supports.

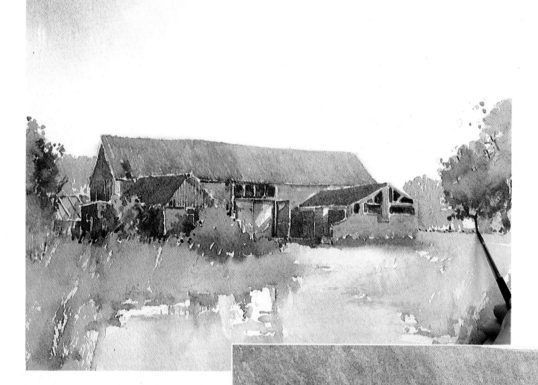

10 | After mopping up the palette wells and changing the water, I used the No. 12 brush to apply yellow into the pathway in the foreground and across the puddled area. Before this was dry I dropped in a mixture of ultramarine and crimson to suggest form and texture. Using a mix of ultramarine and cadmium yellow I deepened the colour of the grass area in the foreground against the pathway, using the side of the brush to achieve a dragged effect.

11 Using a No. 4 round brush and a mixture of ultramarine and burnt sienna I went round the whole painting, making dark marks to bring out the form of the building, adding some posts reflected in the puddle, and darkening the windows in the extensions.

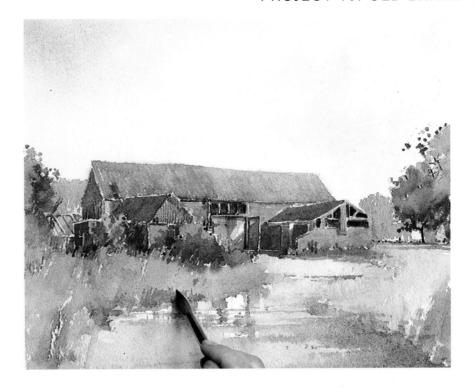

12 I switched to a No. 4 rigger brush and painted the window frames with white gouache, and with an addition of cerulean blue, used this to indicate the boarding on the doors and highlights on the greenhouse. The finishing touches were to add bits of wood and other incidentals up against the barn, and I introduced a deeper shadow in the foreground to make the rest of the painting brighter.

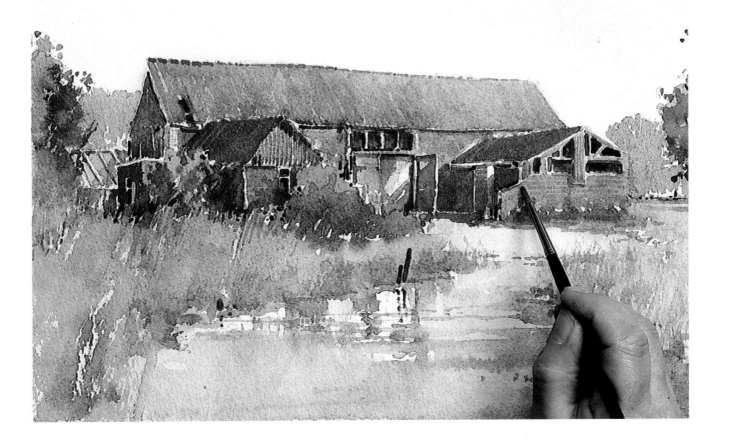

Gallery

The watercolours on these pages have been chosen to show my feelings as a painter. They are not the best or worst of my work, but I believe they capture a mood or atmosphere – I always strive to represent feelings on paper or canvas, whatever way I paint the subject and whatever medium I use. It is important for all artists to remember this attitude, and not to forget it for the sake of commercial gimmicks or quick-fix methods. I hope you enjoy this gallery.

Staithes
380 x 300mm (15 x 11¾in)
With this painting I was aiming to capture a sunlit day with hard edges and cast shadows to remind me of time spent in this lovely coastal resort.

Brent Geese, King's Lynn
240 x 355mm (9½ x 13in)
I tried to create an atmospheric painting with quiet, almost monochrome washes, to suggest a winter scene with the geese flying close to me out of the mist.

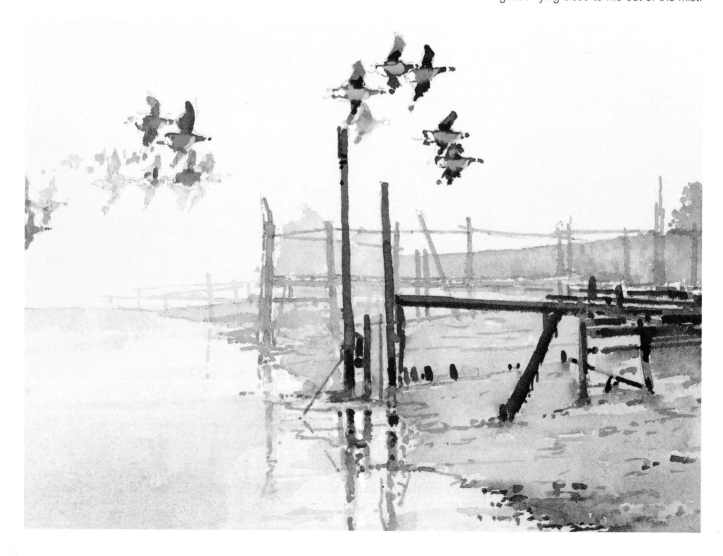

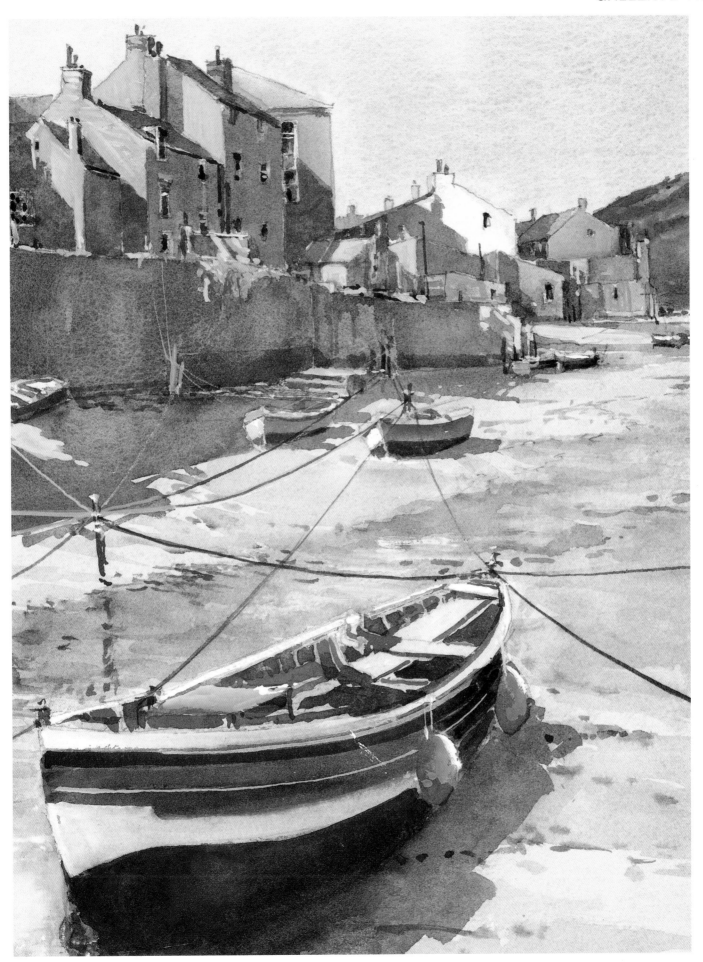

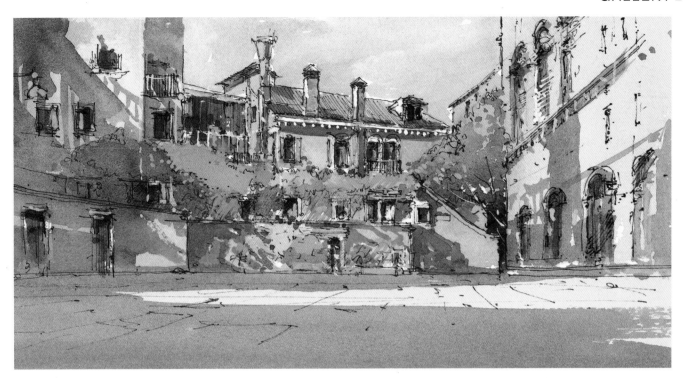

OPPOSITE: **Venetian Garden**
330 x 245mm (13 x 9¾in)
Although I have visited Venice quite
a few times, I was surprised to come
across these almost English back
gardens in a residential part of the city.

ABOVE: **Campo Nuovo**
200 x 330mm (8 x 13in)
This view, painted in pen and wash, uses
the large foreground shadows to create
a feeling of space and calm in the open
space bordered by the buildings.

BELOW: **Gondola Repair Yard,
Venice**
165 x 270mm (6½ x 10¾in)]
In this pen and wash painting I used lots
of sketchy pen lines and a minimum of
colour to get the result I was after.

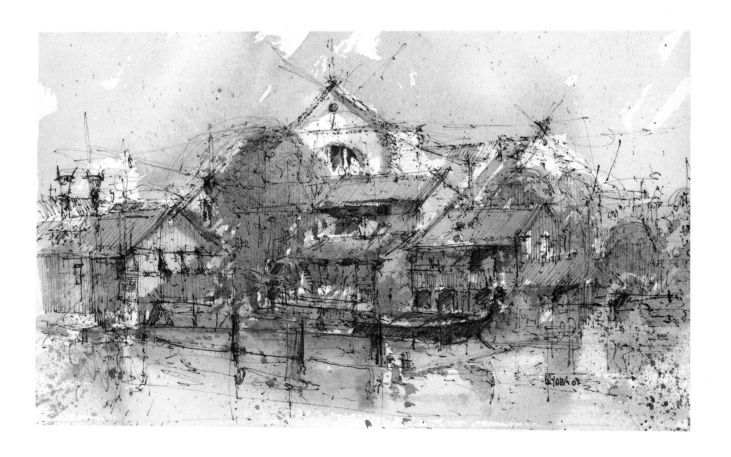

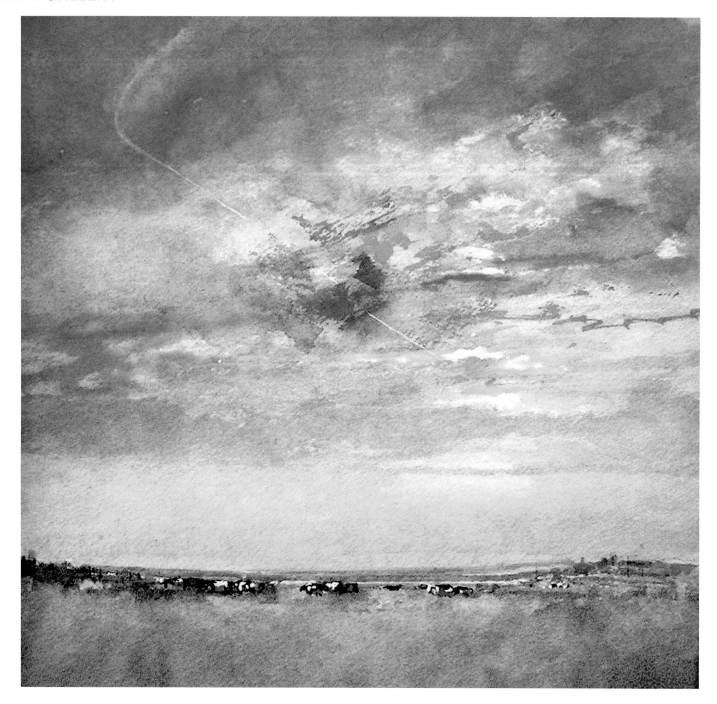

Sunset, Cley

305 x 305mm (12 x 12in)
This is an area of marshland on the
north Norfolk coast, near where I live,
and is a place for birds, backing on
to the North Sea – delightful painting
countryside. The feel is, I think,
somewhat reminiscent of Turner.

Reflections

255 x 190mm (10 x 7½in)
I have painted reflections in the canals
of Venice numerous times, but usually
in oils or acrylics. This is one of the few
watercolours of this special subject
that I think works.

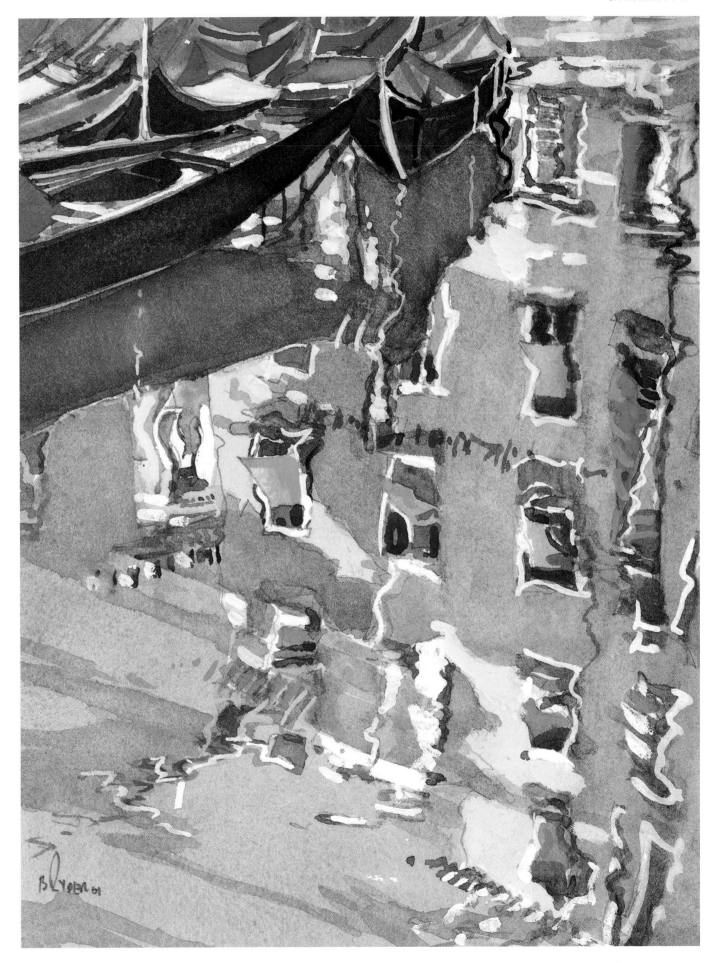

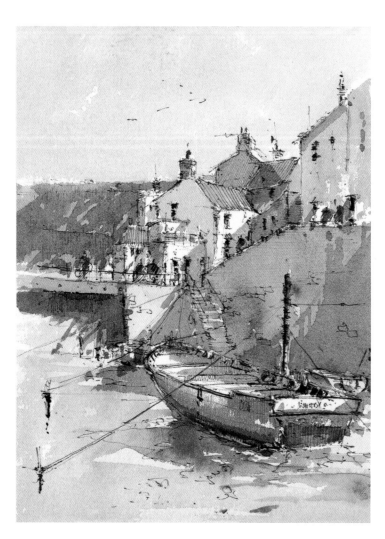

Staithes Beck
230 x 170mm (9¼ x 6¾in)
A pen and ink wash based on my initial pen and pencil drawing on page 9 that captures the feeling of light and shade.

Robin Hood's Bay
220 x 195mm (8¾ x 7¾in)
As a contrast to the view from above, as illustrated in project 8, this pen and wash scene is set down in the harbour of this Yorkshire fishing and tourist village. The sunlit area between the foreground shadows leads the eye to the bright yellow of the building on the left.

Thames Barges 1

330 x 430mm (13 x 17in)
Based on an oil painting by Edward
Seago, this watercolour uses a direct
approach and a minimum of overlays;
I enjoyed doing it and like the result.

Thames Barges 2

275 x 315mm (11 x 12½in)
This is another watercolour based on
a Seago oil painting, but with some
changes. Note the directional sand and
mud that lead the eye across and into
the painting, but which are stopped on
either side by posts or masts.

Conclusion

At the end of the day, most painters have been bombarded with so many tips and 'you must do it this ways' that it is a problem to remember everything you have heard when you are faced with the next painting.

As an analogy, golf lessons seem so understandable when either standing next to the golf pro or reading about the perfect tip for getting out of the rough, but faced with the situation on the golf course, it's difficult to remember the things you have learned when actually trying to play the right shot to reach the green.

Another factor here is that having played a good shot on one hole, you repeat exactly the same thing on the next – grip, stance, swing – and the ball misses the green. It is extremely frustrating, but the pro will tell you it's not 'a game of perfection'.

So it goes in painting: an exact repeat of a subject with the same colours, the same technique and obviously the same experience, does not get the same result. We will all prefer one painting to another, and little bits will go wrong in each painting. When one painting works, immense satisfaction can be gained, but this is not guaranteed.

Learn to accept the little mistakes that happen, but always prepare thoroughly for that shot, apply the learning and knowledge you have gained and do your best, paint swiftly and with confidence, practise and enjoy it.

We all gain inspiration from others around us and try somewhere within our work to 'copy' at least some part of a painting we have looked at and enjoyed. This has gone on through the history of painting, and the very act of trying to achieve in our own paintings the essence of those works we admire, will mean that we can learn through this study of other painters' work and help achieve a better standard once our own style emerges.

Nevertheless, I would advise anybody travelling down this highway to stop off frequently to assess what you are doing. Always be prepared to take time out from your main aim to investigate something new. You never know what other things could lie undiscovered.

Be prepared to work at your craft, and never stop learning. Be open-minded and look at paintings you may consider at a lower standard than your own, as within them you can often find a hidden treasure. And once you feel you have achieved your original goal and people start to praise the work you do, surprise them all and change direction a bit. Aim higher; you might just surprise yourself at the high standard you could actually achieve by trying something new, and which you would be unaware of by resting on your laurels.

Whatever you do with regard to your paintings, remember always to strive to achieve a better painting next time. Observe the world about you, and from this will come the painting that, after all, is only the culmination of all the thoughts and feelings the initial observation gave you.

Enjoy the painting you are doing. If it becomes a chore, take up golf, and then you will understand what frustration is all about! Plan and draw with care, think before you paint any section of your work, then think again, then paint every section of your painting boldly and swiftly and… with confidence.

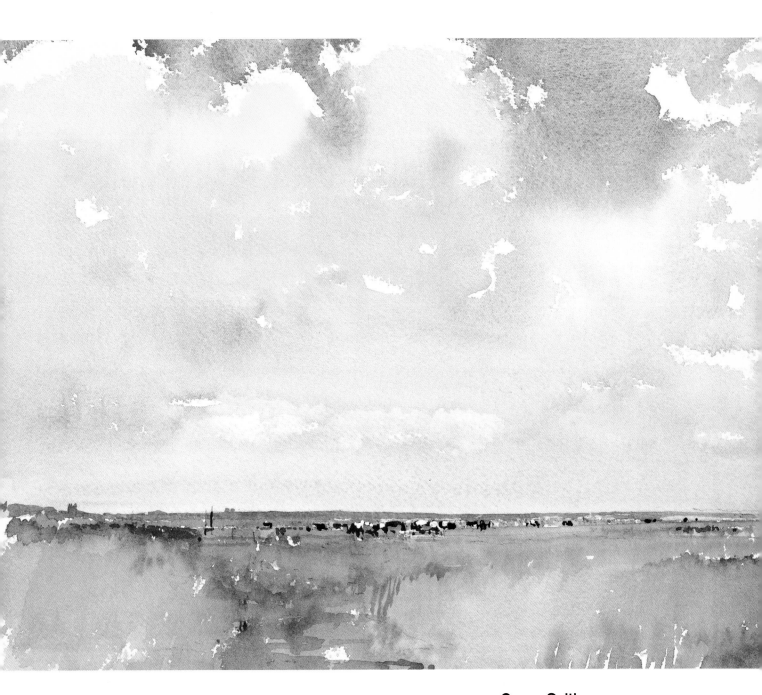

Cows, Salthouse
315 x 380mm (12½ x 15in)
This is a typical scene on the marshes
of north Norfolk, and one that I never
tire of painting.

Index

Acknowledgements

I would like to thank Viv Young for making sense of my garbled messages and my initial typing of the text, and for putting this together with the paintings to make the book coherent.

I must also thank Ian Kearey for all his help and sound advice.

Thanks go to all of my fellow painters and friends, all the students I have ever come across, and all those subject to my teaching methods – without them all, this book would not have been possible.

Finally, my thanks go to the team at David & Charles.